HAUNTED PLANTATIONS

Ghosts of Slavery
and
Legends of the Cotton Kingdoms

Escaping Ghosts

In the still sun, we walk through stalks
Of green, stepping slowly, through the phantasmal
White heat of August.
Clinking sounds drift into memory as open ears
Listen far into Elysium outer fields.

Saving skin, mystery defines the only answer
Notice the mirrored echo?

Wandering through as aging husks spin
Like whirling comets, magnolias and cotton carry—
Harvesting, evolving, ever growing
Revolving, like terror's doors
With an unquenchable fire inside.

HAUNTED PLANTATIONS

Ghosts of Slavery
and
Legends of the Cotton Kingdoms

Geordie Buxton

ARCADIA
PUBLISHING

Published by Arcadia Publishing,
Charleston SC, Chicago IL, Portsmouth NH, San Francisco CA

Printed in the United States

Library of Congress control number: 2007928720

For all general information contact Arcadia Publishing at:
Telephone 843-853-2070
Fax 843-853-0044
E-Mail sales@arcadiapublishing.com
For customer service and orders:
Toll-Free 1-888-313-2665

Visit us on the Internet at www.arcadiapublishing.com

Photographs by Jayson Polansky, Geordie Buxton, and Jim Kempert.
Historical photographs courtesy of Historic American Buildings Survey /
Library of Congress, Prints and Photograph Division, Washington, D.C.

For tour information, visit www.walksinhistory.com

CONTENTS

To all who survived the crossing.

I have never seen a ghost.

I do believe there is life after death, even that life itself is deathless, but I cannot say with any certainty that a spirit can linger in the world once the body is diminished. In all the interviews and research compiled to make this book a reality, I found some patterns in the legends and folklore that people do believe. First of all, every reported ghost sighting led to historical evidence of a life cut short, a premature death usually by tragic and sudden means. It seems every ghost has some sort of attachment to the place where its life was uprooted. In some cases the attachment is to something in the physical world, like the remains of a plantation. In others it is to things less tangible, such as cultural beliefs. I found that every story contains a sense that the spirits are somehow trapped in the upheaval of their past lives. They appear crystallizing around their loss, replaying their final moments as if on an eternal film loop.

In your hands are pages that many authors have thought about writing. These are documented stories, folklore, and legends wrenched from the gravest parts of America's past. Yet many authors, especially if they have identified themselves as southern, may have realized that dwelling on the affairs of slavery and plantations is to tread into the fires of emotionally raw and dangerous places. Set primarily in the coastal South Carolina and Georgia Lowcountry of the

Christ-haunted south, these are accounts of souls lingering from love and glory in ruins to the reckoning of early America with its harrowing system of human slavery. While much of the contents relate encounters with the supernatural, even the casual reader will find that the history of what actually happened in this part of the country doesn't need ghosts to be any more haunting, macabre, or enchanting.

These are stories about real people who lived real lives much like we are living right now. The documented accounts of their lives and deaths match what people have either written down or sworn that they witnessed. If you are going to thumb through the contents in hopes of finding Casper the Friendly Ghost, you must know right away that you are holding the wrong book. And for those who yearn for the type of story orchestrated by Hollywood, then— once again—this one is not for your sheepish eyes. The stories collected in this book were derived from audio taped interviews with people who have a lot more to lose than just their reputations, as well as from the dusty archives in some of the most remote locations imaginable around the swamps and tidal creeks of the Lowcountry.

There are three types of ghosts that are touched on in this book. One is the most popular notion of a ghost: a slightly translucent, wispy entity seen in the same place, wearing the same clothes, acting out the same routines as if stuck inside the maddening repetition of a skipping, silent movie. Most parapsychologists, such as those from the former Rhine Research Institute at Duke University, believe these spirits have very little awareness that we, the living, are here. (Most of us have very little awareness that they are here either).

Another type, and usually the most frightening of them all, is the poltergeist. Poltergeists are rarely ever seen; however, they can penetrate just about every human sense aside from sight. They can be heard as voices, sometimes in packs, and can also manifest via 30- to 40-degree temperature drops next to one's side. Poltergeists also seem to be able to affect anything with electromagnetic frequency—lights, radios, even television. They can come in the form of smells like cigar smoke, perfume, or barnyard hay, to name just a few. It's as if we, the living, are on an AM radio frequency and they are on a powerful FM station. Poltergeists are claimed to be able to cross over the channels in the same way that mediums and clairvoyants, such as the one discussed later in this book, can cross over into their world.

The third type of ghost discussed in *Haunted Plantations* can be referred to as an angel. Angels appear to be souls that tried passionately to do something good in life, such as stopping a mate from going into battle, saving someone from a natural disaster, or simply trying to keep a loved one from smoking too many cigarettes. In the process, this good person somehow died prematurely and their spirit lingered on Earth, eternally trying to deliver its urgent message.

No one should expect to actually see a ghost or experience anything unusual upon making a visit to any of the locales covered here. This book is not a map to a supernatural petting zoo. Documented ghost sightings, though often commercialized, still are rare—a person is considered lucky if they become a witness to the supernatural. In brief, do not go to these places and expect to see spirits on demand.

Respecting the dead is a necessity in the Lowcountry, where nearly every inch of earth and marsh could easily

be some past village's burial ground or the site of some terrible tragedy. The land here is alive with memories—often unpleasant memories like those from the days when Charleston was the main American port for the plantation system's international slave trade. In addition to the brutality and suffering inherent in that system, many slaves stood as silent witnesses to some of the worst scenes in America's early history. What they saw and heard went with them to their graves. Although the United States outlawed the exchange of enslaved humans across the Atlantic Ocean at the end of the 18th century, the practice continued along the coasts of Georgia and South Carolina through the Civil War. The extreme wealth gathered by a few in early America was too often derived from the pain and fear of shackled men, women, and children, whose spirits may very well have been too troubled to find rest even in death.

Sifting through the folklore and ghost stories of this region—reading the stories of the people who lived here and died here—can ignite once again the old hushed embers of the South's past. Fire, associated with so much fear and destruction throughout the history of the South, has also been associated with purification and redemption. Entering the flames of these haunting stories, my hope is that the spiritual jewels that lay in the ashes of all the ruins can be found and redeemed.

Geordie Buxton
November 7, 2006

HAUNTED PLANTATIONS

Ghosts of Slavery
and
Legends of the Cotton Kingdoms

PART I

Legends of the Cotton Kingdoms

THE MYSTERIOUS DEATH OF
WILLIAM HENRY DRAYTON

*T*here is a narrow staircase in the middle of the Drayton Hall plantation house that leads to an empty upstairs room where a ghost is said to reside. The spirit has never been seen, but it lives in the walls of this room in the Drayton family home. Custodians and historians have felt temperature changes upon entering the room and sensed an unseen presence next to them.

According to renowned clairvoyant Elizabeth Baron, it is William Henry Drayton's soul that lingers there. In his living years, family members locked him in this isolated room when he became rowdy during heated political meetings. Drayton Hall was a hotbed for intrigue during the years before the Revolutionary War, and Drayton was known to become intoxicated with both liquor and a manic patriotic fervor.

William Henry Drayton was born in South Carolina in 1742. He was the son of John Drayton, the builder of the magnificent brick plantation house on the Ashley River, west of Charleston. William was the first Drayton son and was educated in England. He went on to political fame as a congressman and was a major force in the American independence movement. Like his father, he was greatly revered by Whigs on both sides of the Atlantic. He organized

much of the planning for separation from the crown in the plantation house, and he considered those who were not part of the rebellion traitorous enemies.

Drayton was reported to have died mysteriously in Philadelphia at the age of 37, in 1779. Given his passion for the revolutionary cause, it is likely that he was killed in a pistol duel. If true, the fact would have been hidden from his family to spare them the shame.

After Drayton's body was shipped back to Drayton Hall, the family inheritance was passed to his younger brother, John. The next year, the British seized Charlestown and the Drayton family and its patriotic allies were forced to tolerate British occupation for nearly three years. It could be that William Drayton's violent death in the heat of passion—and the subsequent occupation of his homeland by his hated enemies—somehow caused him to return to the scene of so many of his emotional political battles. If so, he would be one of the most obvious candidates for ghostdom in the Lowcountry.

Walking across the lush green lawns of Drayton Hall, it is easy to drift back to the 1770s, when men gathered there to voice their opinions on unjust taxes and high-handed royalty. This house is the only in Charleston to have survived both the Revolutionary and Civil Wars, and there is a sense there of time suspended, of events from the past being somehow closer.

Some historians have claimed that William Drayton died prematurely because of a weakened immune system caused by overwork. The man was known to engage fervently in

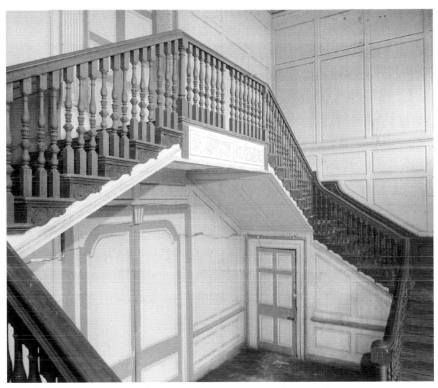

William Henry Drayton was locked into an upstairs side room in Drayton Hall when his temper flared at family political meetings. The reason for his untimely death at age 37 in Philadelphia during the Revolutionary War remains unknown.

meeting after meeting to ensure the success of the family plantation and his political career. He traveled extensively to meet with other American revolutionaries. However, the age of 37 is the physical peak of most men's lives, making it difficult to believe that Drayton's energetic spirit and body would give way to sudden illness in his prime.

In 2000, Elizabeth Baron was brought to Drayton Hall to determine if the hauntings many at Drayton Hall had experienced were real. The Charleston medium has worked with people from all walks of life around the world for nearly 30 years. She has given hundreds of readings throughout her career and delivered psychic messages to thousands through channeling the spirit of a 13th century nun, Saint Catherine of Siena.

During an episode of Home and Garden Television's *America's Most Haunted Houses* series, Baron described the pain still lingering from the life of William Henry Drayton. She told a haunting story of sensing Drayton's spirit and said she felt the strongest presence at a small back stairway leading to an upstairs room:

> I've tuned into a lot of ghosts, but I have never seen a place as haunted as this . . . there are a great many spirits that need to be freed . . . I believe he was a tormented soul. He was too much into the physical, so he started drinking and womanizing . . . there is a lot of suffering. Something lives up there. This William was put up here and wasn't allowed to go to those big meetings anymore, until he was finally hauled off.

Baron's report from the other side makes Drayton's death even more mysterious. Could it be that his hatred of British authority carried over into his personal life with his prominent father at the plantation house meetings? Was William Drayton's patriotic stance as clear in these meetings as history has written it to be?

Only William Drayton and perhaps his family and closest colleagues knew the true reason for his untimely death. His friends sent word that he had passed away suddenly of illness, but the real cause may have been a much darker secret. Whatever the reason for his death may have been, his spirit lingers in the darkness of the room at the top of the stairs in the old plantation house. According to Baron, William Drayton's voice calls out from the walls: "I am here because I want to be."

Edisto's Brick House Bride

*T*he ancient mansion sits like a burned tinderbox in the fields of the old Paul Hamilton Plantation on Edisto Island, South Carolina. The remains of the Brick House, which dates back to 1725, stand as a humble symbol of the Lowcountry's plantation decadence, ruined by the passage of time.

While the plantation was once vibrant and wealthy from the profits of cotton, the Brick House today is a cold and lonely sanctuary for the ghost of a bride, murdered by her ex-fiancé on the day she was to be wed to another. She is believed to be Amelia Candace Hamilton, a haunting apparition spun from a tragedy of the heart.

Amelia was betrothed to a man from a prominent Charleston family while she was still quite young. The suitor had a ring created for her that was large and dazzling. Amelia soon fell more in love with the ring than the man. Her fiancé took her out to lavish dinners and social gatherings in order to introduce her to Charleston society. At all the functions, Amelia placed her hand out in order that people might see her gorgeous ring.

At a large dinner party at a country house between Edisto Island and Charleston, Amelia met a wealthy young planter. The man commented on how beautiful her ring was and how

it reminded him of a miniature version of his grandmother's wedding ring. The two immediately fell in love.

Over the course of that summer, Amelia gathered the courage to write to her fiancé in Charleston to explain that she no longer loved him and wished to break from their engagement. The Charlestonian refused to accept her rejection of him. Upon receiving her letter, he rode quickly to the Brick House and demanded an explanation. Amelia explained that she desired another man. The Charlestonian began to beg, but his words fell on deaf ears. His pleas turned to rage when Amelia demanded that he give her space with her new man. As he got on his horse to leave, he turned to her and snapped, "I would rather see you dead than marry another man!"

Years later, the day arrived when Amelia was to wed the wealthy planter. Her ex-fiancé's death threat had long been forgotten. She had neither spoken to him nor heard of him since he left in a rage the day she rejected him. The lush lawn next to the river was decorated with flowers, lanterns, and chairs for Amelia's nighttime wedding. An altar was arranged in front of the backdrop of the river.

The guests arrived at the Brick House on horse and by boat from all around the area. The plantation was filled with decadent flowers, food, and music. There was a private steamboat waiting by the dock to take the wed couple to Charleston after the ceremony.

Upstairs, Amelia dressed for her wedding. Above the music and laughter of the guests, she recognized a voice from the past calling out her name. The voice came from outside. She opened her window and looked out into the twilight. Next to a lantern, she saw the silhouette of her

former fiancé aiming a pistol at her. As she screamed, shots broke out. The music stopped.

The wedding party rushed upstairs to find Amelia. The first to reach her was the bridegroom. He found her face down on her bedroom floor. He tried to help her up, but she was already dead, her white wedding dress heavily stained with blood. On the sill of her open window, there was a red handprint left by Amelia as she fell to the floor. Her bridegroom looked outside to see Amelia's forgotten fiancé standing with the pistol still in his hand. The bridegroom reached for a pistol himself, but there was no need. The forgotten suitor turned his weapon on himself. One more shot rang out, and the Charlestonian fell to the ground like a brick from the Hamilton mansion.

Today a woman in a wedding dress sometimes appears at the upstairs window of the burned remains of the Brick House. Her dress glows in the moonlight and her appearance is accompanied by the sound of music in the wind blowing off the river. The engines of an invisible steamboat can be heard with the lapping of the waves next to the old Hamilton lawn. All of this, according to local folklorist Virginia Marin, occurs on the anniversary of Amelia's wedding day, August 13.

The most tangible evidence of Amelia's ghost in the Brick House is on the windowsill her bloodstained hand fell upon after she was shot. Many attempts were made since the tragic day of her wedding to cover the print at the window, but it continued to bleed through coat after coat of thick dark paint. The interior of the grande manse

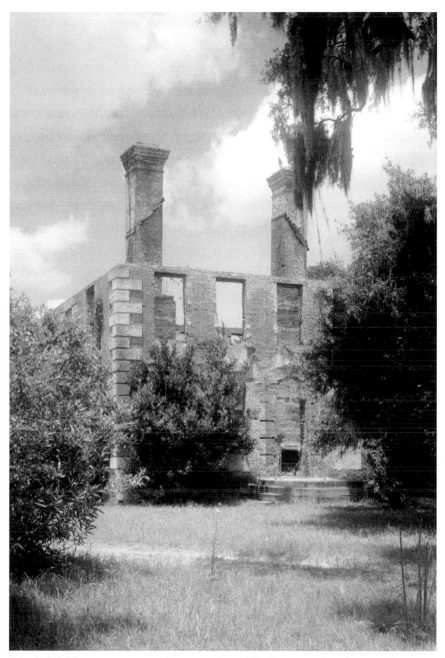

The Brick House was once vibrant and wealthy from sea island cotton. It is now the burned sanctuary of a bride who never made it to the altar.

was gutted by fire long ago, but to this day, red lines can be seen around the eroded exterior of the window Amelia opened on her wedding night. They are a reminder of the sometimes-tragic consequences of unrequited love and unhealed heartache, and the remains of an eroding past that has refused to fully depart.

THE RAVENEL LIGHTS

*M*any people have gone to the railroad tracks behind an old Baptist church near Ravenel, South Carolina, for a ghost hunt. Where the railroad turns just before the highway, three eerie lights are said to appear moving silently up the tracks. They disappear, leaving witnesses in a spell of darkness, only to reappear closer. When the Ravenel lights reach the bend, they fade into a dark rush of wind and phantasmal images.

According to local legend, people wishing to see this supernatural phenomenon must knock on the Baptist church door three times in the dead hours of a moonless night. They are to then walk away from the doors on the road towards the town. They must travel parallel to the railroad tracks that are behind the church graveyard, between Martin and Drayton Streets. As they come to the bend in the tracks the Ravenel lights flash slowly, like a signal, while moving ever closer to them.

One group of witnesses claimed that after the lights disappeared at the bend, the side of their car was pelted by moving objects. Later, they discovered the impressions of hands on their doors. These dented doors were the ones that faced the railroad tracks—and the approaching lights.

On another occasion, a group on foot reported a strong wind rushing over them and through the tree limbs overhead as the lights disappeared.

Others in a pickup truck claimed that dark bodies tumbled quickly across their vehicle, wrecking their hood and leaving a crack in the windshield. When they opened their doors and looked around the area with a flashlight, everything looked in place except for the fact that their truck was now dented. They saw no movement from anywhere. The woods and the distant highway were completely mute, yet there was a distinct smell of smoke in the air. This silent aftermath was more alarming to them than even the lights themselves, they reported, so they returned to their damaged truck and drove away.

Three unmarked wooden grave markers sit in the back of the Baptist church graveyard. The Ravenel railroad tracks can be seen over granite rocks directly behind the graves. Although there is little evidence to prove any of the elaborate stories surrounding the Huguenot-founded town of Ravenel, oral tradition dates the three eroded grave markers back to the turn of the 19th century, when the small farming town was constructing its first train depot.

It was New Year's Eve 1899, and a low orange moon was slowly setting over Ravenel. It had been a night of heavy celebration for three young men. After making brief appearances at every home offering cocktails for the occasion, they tied their horses and walked from one plantation party to the granite hill of the railroad tracks to toast one another at the new train depot construction site.

When they got to the tracks, they headed up the rock embankment. Suddenly, half of the enormous orange moon appeared glowing above the woods like a great mythical

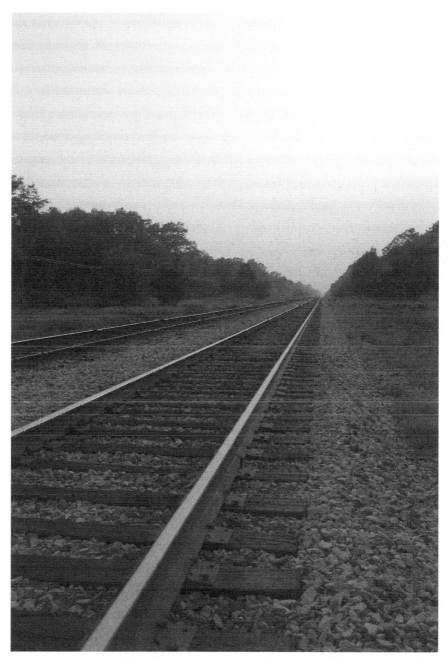

Ravenel's first train depot was built near this stretch of track at the turn of the 20th century, when stories of the phantom lights began to be told.

bridge. The Ravenel men stood solemnly. They gazed at the moon as if looking to a great altar, a cathedral of light built in their names. The unfinished depot stood nearby.

The Ravenel men's fascination with trains was enhanced by their thrill-seeking nature. Each of them worked at a depot within an hour's horse ride. The locomotive was the fastest, most powerful thing ever seen at the time, and these men were thoroughly mesmerized.

Without radio or any kind of electronic communication, the only way to signal a train conductor was by Morse code, with lights. The three men performed this function, acting as vital messengers from their respective depots, controlling the movement of locomotives along the South Carolina railroad system.

Since the arrival of the first American railroads, most Ravenel families had left plantation work to be on or near the tracks. Nearly every section of the track that ran from Charleston west to Hamburg was soon populated with small towns similar in size to Ravenel, creating communities where transportation was accessible. Soon tracks were laid going east towards Charleston, South Carolina and on to Wilmington, North Carolina. Inland South Carolina towns near the rivers around Columbia, such as Camden, the oldest inland town in the Carolinas, thrived. The railroads freed the plantation system from its dependence on navigable water and horses.

The Ravenel men, whose families were involved in the new commerce, had a vested interest in the depot. A train stop would diminish the cost of transportation to get their crops to the markets of Charleston, Beaufort, and Savannah.

Although the depot was not yet completed, the Ravenel men's feverish energy, combined with the rush of their earlier celebrations, led them to believe they could do anything. The appearance of the enormous orange moon seemed to lend them some validation.

A small coal engine and box car was kept outside the depot. As if it were just another horse, the men hopped on and quickly got the coals lit, giving power to the train. They soon felt the need for a joy ride. Unfortunately, none of the men were aware that work cut off early for the laborers that day, and none of the tracks leading out from the depot were completely nailed down.

As the engine roared in fire, the dark steel machine picked up speed. The men whooped and hollered in glee. The woods lit up from the glare of the engine coals as they passed by. The youngest of the Ravenel men was even moved to blow the steam whistle to let all the outlying plantation parties know which men were changing the face of this Southern land through their work on the railroad. The men leaned out the side of the train to glance behind them at the candlelit houses. They turned back to see what lay ahead on their joyful journey. They never looked at the plantation houses again.

As they approached the bend behind the Baptist church, they were moving at top speed. With 20 yards of rail missing on the left side of the bend, the train sailed directly off the embankment in silence. Then the ripping of the loose metal rails made a high-pitched, grating screech and fiery sparks shot into the air. The train landed on its side, exploding immediately into a ball of flames.

From the balconies of homes in the distance, the people of Ravenel saw the setting of the orange moon replaced by a closer, brighter glow between the depot and the church. The townspeople rushed down to search for survivors, but when they reached the scene of the incinerating fire, they were unable to locate any remains of the three Ravenel men.

Duncan's Storm

*T*he 15-year-old African American Daniel Duncan never spoke a word after he was hanged in downtown Charleston before an uneasy audience on August 9, 1911. No one ever reported seeing his ghost. No mysterious lights appeared near the sight of his execution and no phantom bells were heard in the wind that blew off the harbor and through town that day. But the persecuted soul of an innocent young man nevertheless cast a long shadow over the conscience of the Holy City.

As had been the custom since the early days of Charleston hangings, Duncan's body hung for three days. This exploitation of an executed man was the most severe message of the town's justice system. Punishment was to be served for those who broke the law. Husbands and wives walked by the bleak gallows on their way to church, nodding at their grimacing children as if to say, "Pray hard and do good or this could be you!"

But most people in Charleston, both light and dark skinned, knew that shy Daniel Duncan was in no way capable of harming any person, much less murdering one. But the question of whether the boy was or was not a murderer wasn't the cause of the uneasiness that manifested itself in nightmares for many of the city's residents. During the nights Daniel hung silently near the College of Charleston, everyone knew that the young man was never given a trial.

Since the Emancipation Proclamation, every African American was to receive the right to a fair trial if charged with a crime. But the justice system had inexplicably reverted back to plantation days. Something had gone terribly wrong in Charleston that summer, and the God-fearing folk of the Holy City trembled over what might come from this travesty.

Duncan was found by Charleston police fishing on a broken pier along the Ashley River, west of downtown Charleston. He was questioned about the murder of a 73-year-old woman on East Bay Street. Charleston, still fiercely segregated at the time, was in an uproar to convict someone—anyone. The search for the murderer had stretched beyond three months, and the tight-knit fraternity south of Broad Street was getting frustrated with Charleston's police. The authorities had yet to turn up a single suspect since the night in May when the woman's throat was slit.

With threats from Charleston's elite and powerful residents, the police panicked and began to loosen their criteria for finding a suspect. Daniel Duncan happened to be an available target for what had become a witch hunt. When he was handcuffed and taken in for questioning, the young man could only respond in a thick Gullah dialect. His speech was barely intelligible to the interrogators. The police had found the perfect scapegoat: a suspect who could not communicate with them in order to defend himself.

That day, the Charleston police announced that the case was solved. In their rush to redeem themselves in the eyes

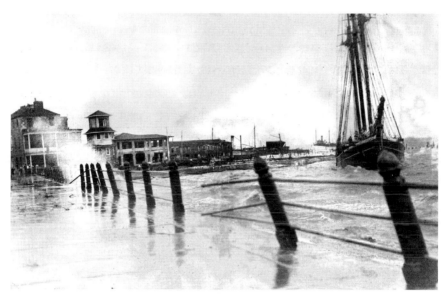

This picture shows the swelling waves of the 1911 August tempest that struck Charleston. After the wrongful public hanging of young Daniel Duncan, the cyclone was dubbed "Duncan's Storm"—God's retribution for the death of an innocent man. (Courtesy South Carolina Historical Society.)

of prominent Charlestonians, they quickly arranged for Daniel Duncan to be executed that Friday. On the very day the papers announced that the murder mystery had been solved, Daniel Duncan already had a rope around his neck. Those who knew him cried in protest, but the police kept them away with pistols and clubs, all the while persisting in calling Duncan a monster and a beast. Very soon, Daniel Duncan was dead and on display.

By the next day, Duncan's eyeballs had rolled inward. Bodily fluids and excrement had dripped down to his toes. His flesh fell prey to birds, and maggots could be seen crawling in and out his body. What remained of his skin was scorched in the heat of the August sun. And what the birds didn't get off his hanging body, crabs eventually picked off the ground. And all this was just the visual horror of Duncan's hanging—his decaying body's stench spread over two or three city blocks, a grim reminder from the police that the town was safe again.

On the third day, the skies turned black around the Charleston peninsula. All the nightmares residents had been having for the past three days appeared to manifest in their waking lives when tidal waves rose up nine feet on the Ashley and Cooper Rivers that surrounded Charleston. The waves came crashing down, drowning some of the residents who could not find shelter or higher ground fast enough. Gale force winds pushed ships over the Battery seawalls. Twisters ripped through the cobblestone streets and alleyways as the full fury of a category three hurricane descended upon the Holy City.

As the tidal surge grew higher and the relentless winds increased, Daniel Duncan's body was suddenly ripped

from the gallows. The Charleston justice system had turned on itself, and Mother Nature had come to wash away the crime.

Public hangings ended in Charleston after Daniel Duncan's execution. A street was named in his honor soon after the storm. The superstitious minds of the Holy City truly believed the hand of God had come to serve retribution for the death of an innocent man. Known in history books as the hurricane of 1911, the tempest is forever known to older Charleston residents as "Duncan's Storm."

WAMPEE HOUSE

*T*he Southern Gothic mansion sits on the shore of Lake Moultrie. With its well-documented history of paranormal phenomena, many have called the Wampee House the most haunted place in Berkeley County. Native American burial mounds inhabit the area. The Wampee plantation's local Biggin Hill Church burned down three times. Across the lake from the house is the hydroelectric plant of the state-owned electric and water utility Santee Cooper, which owns the house and uses it as part of its conference center. The plant bellows white steam across the dark lake and from a distance, shadows dance slowly in the old plantation house's windows.

People have proposed that there are many ghosts that inhabit the Wampee House. There is a cold spot in one of the bedrooms where the caretaker's dog will not go. Tiny white lights have been seen moving across the porch. The sounds of doors opening and closing for hours on end have kept Santee Cooper board members up through the night. A visiting New York businessman awoke once to see a face hovering above his bed. Clothing has been moved across bedrooms while guests have slept. The events are too many to list, but have led some to hypothesize that the ghost is that of a pirate who wandered off while unloading a ship at nearby Stony Landing. Others, who claim to have seen a full apparition, believe the ghost is that of a Wampee Indian

maiden who lost her life following her mate into battle with European settlers.

In one of the Indian mounds on the property, excavated for the Charleston Museum several years ago, the remains of a Wampee woman was unearthed. She was buried in a crouching position, as if on guard. Little is known of her history, but the spirit of an Indian woman with what has been described as a porcelain face was witnessed at the Wampee House shortly after the excavation. The ghost has been seen visiting every room of the mansion and all around the surrounding premises, vanishing as mysteriously as she appears.

The name Wampee is thought to have referred to a water hyacinth with a blue flower, found growing in low marshy areas like the headwaters of Lake Moultrie. The name is also said to refer to the "wild rice" eaten by birds common to the tribe's hunting grounds. The Wampee House ghost, according to the Charleston newspaper *The Post and Courier*, wears a garment of flowing blue silk, seemingly made of these local water hyacinths, with matching "Cinderella-like" slippers.

The Wampee were one of many distinct indigenous peoples who inhabited the Lowcountry at various times leading up to the rise of the plantation era. It is easy to become lost in a list of the names of the local tribes. The ones that start with "W" alone are expansive: Wambaw, Wampanchecoone, Wando, Wantoot, Wapoo, Wappaoola, Wappetaw, Wappoo, Washasha, Washo, Washua, Wassamassaw, Watcow, Wattesaw, Wedboo, Weehoy, Wespanee, Westo, Weastockon, Wimbee, Winn, Wisboo, Wiskinboo, Woosah, and Wosams. As the plantations

started to thrive, the natives were driven out or enslaved to work alongside Africans in the miles of rice fields.

Baptists established the Wampee plantation in 1696 as St. John's Parish. The present house, erected sometime after 1822 when the plantation was prospering through rice cultivation, was the third built on the property. At that time, the land was occupied by Charles Macbeth, the mayor of Charleston during the Civil War. Traces of the two older houses can still be found on the property. The house was acquired by Santee Cooper prior to the building of Lake Moultrie, which covers much of the original Wampee plantation lands. The present Wampee House is much smaller than the others of St. John's Parish because of an event that happened during its construction. When all the framing was set in place, a violent tornado struck the house. The force of the wind broke off all the framing near the sills, so the builders sawed off the broken timbers and built the house on proportions smaller than planned.

According to an October 1997 *Post and Courier* interview with Santee Cooper board member Mac Walters of Greenville, the Wampee House ghosts are real. Walters, who was head of the Internal Revenue Service during the Nixon administration, was overcome by what he heard during the night he stayed in the old plantation house:

> He awoke in the middle of the night and felt a presence that forced him to keep his eyes closed. His body was straight and his hands were clasped across his torso in a funeral fashion. He could not move. The sound of doors opening was interrupted by an alarm at 4:30 a.m. It was set

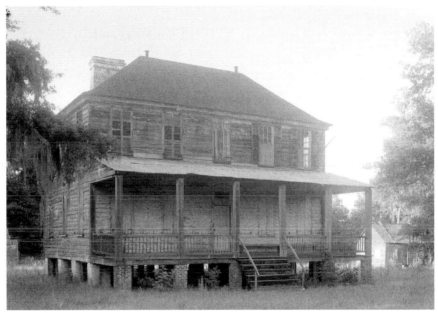

The Wampee House on Lake Moultrie has a long history of documented paranormal activity.

for 6:30 a.m. He never went back to sleep and heard doors opening the rest of the night. . . . Five weeks later, he wrote about his stay at Wampee, saying he still had not gotten over that night and would resign from Santee Cooper's board if he had to stay there again.

The last caretaker of the plantation house had her closest encounter with a ghost as she was putting china away in the main dining area. The light was fading and from the corner of her eye she noticed a figure on the other side of the window outside on the house's front piazza. She turned and saw a clear image of a young Indian woman looking directly at her until it slowly vanished with the setting sun.

THE CHURCH ON BIGGIN HILL

*J*acob Skelen leased a unit in an apartment complex set beside a hill in the fall of 2004. During his first week, he found a letter in the pile of junk mail in his mailbox addressed in a cursive hand in faded ink to Current Resident. The return address was Biggin Episcopal Church, Saint John's Parish, South Carolina, with no zip code. The envelope was aged, brittle, and sealed with burgundy wax. The old wax flaked off almost as soon as he picked up the envelope.

Skelen opened the letter and pulled out a similarly-aged, folded paper stained indigo blue. He carefully unfolded the paper to keep it from breaking apart. As he held it up, he saw an image of the head of Jesus crowned with thorns, his eyes closed. The edge of the paper was frayed and stained yellow. There was a note that accompanied it asking, in the same faded cursive ink, for him to kneel on the end of the paper and use it as a prayer rug. It also said that if he kneeled and prayed from the Book of Psalms that he would have his "prayer planted, harvested."

Skelen was about to toss the letter into the trash when he noticed the next line, which said that the image of Jesus, with its eyes closed, would awaken upon his kneeling on the paper, praying the prayer, and looking directly into the image. Skelen's curiosity was aroused, so he placed the paper on the floor and knelt on the edge. He recited the King

James lines from Psalms and looked at the image. He saw the same image of Jesus, but this time the eyes appeared glowing, wide open, gazing directly into his.

Skelen jumped off the paper and stood back. He saw the same closed-eyed Jesus as before. He picked the paper up and examined it. After turning it from side to side, he saw that the eyes appeared open when viewed from different angles and reasoned that the image's effect was merely the result of a watermark.

He finished reading the letter. The church asked him to write a prayer request, place the prayer rug and request back into the envelope, enclose an offering of his choice, and send it back to Biggin Episcopal Church. The letter concluded that Jesus would hear his request and that the Holy Spirit was always watching him and would pass by his window that night.

The night was moonless, with few clouds. The huge oak trees around the apartment complex made sad autumn music. Skelen lay in his bed for hours anticipating a celestial spirit passing by his window. He couldn't believe in anything he couldn't see, but a spirit outside his window would change that, he figured. It would be challenging for him to extrapolate the existence of a deity from a vision of a single ghost, but just one spirit could imply a whole unseen universe of phantoms, demons, angels, and miracles. The thought frightened him. He turned and slept with his back to the window.

Nothing out of the ordinary happened that night that Skelen could remember the next morning. He wrote down a request to experience a ghost on the letter. It didn't have to be "The" ghost, he added, any ghost would be fine. He

placed it in the outgoing mail slot and thought little of it over the next month.

Biggin Episcopal Church was originally built in 1712 as an Anglican Church on Biggin Hill by Reverend Robert Maule. The minister was an Anglican missionary from Maine who was assigned to the Parish of Saint John's, Berkeley, by the Church Act of 1706 that created 10 parishes in the province.

The long, narrow shape of Saint John's Parish resulted in centers of growth in widely-separated communities. These community interests caused the parish to be divided into Lower, Middle, and Upper Saint John's. Biggin, the parish church, was in the upper part of Lower St. John's, on the border of Middle Saint John's.

The site took its name from Biggin Hill in Kent, Great Britain. Many nearby plantations including Pooshee, Wantoot, Fair Spring, Hepworth, Chelsea, and Indian Field thrived along the banks of the Cooper River and Lake Moultrie. Saint John's, Berkeley is said to have been the part of South Carolina where cotton was first successfully and profitably produced. The crop was picked by slaves and placed on boats that carried it down the Cooper to the port of Charleston, where it went on to commercial ventures in the rest of the world.

A forest fire destroyed the first Biggin Church in 1756 and it was replaced in 1761. The brick ruins that remain in the graveyard today are of this second pre-revolutionary Biggin Church of 1761, according to local historian Samuel Galliard Stoney.

In 1781, the second Biggin Church was burned down by British troops under Colonel Coates while they were retreating toward British-occupied Charlestown that July. After the Revolutionary War, the church was restored once again.

During the Civil War, the third Biggin Church was stripped of its pews and metal fixtures, which were used to support the Confederate army. The church remained bare and abandoned for the duration of the war.

One December evening in 2004, Jacob Skelen had just arrived back at his apartment complex after work. He parked his car and walked up to the security door in the dark. The wind whistled through the trees as he punched in his code to open the door. He entered the complex and walked up a flight of stairs to his apartment. The halls were quiet as usual as he unlocked his door and stepped inside. Skelen sat down on a chair in his living room to take his boots off and as he did, he noticed an envelope underneath the door he had just entered.

The envelope was halfway under the door. Skelen picked it up and saw that it was as aged and brittle as the one he had received in October. It was from Biggin Episcopal Church, Saint John's Parish. But this time the envelope also bore his name in cursive at the top: Jacob Skelen. He unlocked his door and opened it slowly. He peered out into the hall but saw no one. He walked to the stairs and looked down into the hall below him. Again, he saw no one.

Skelen stepped back into his apartment. The burnt burgundy wax crumbled away as he broke the seal. He slowly

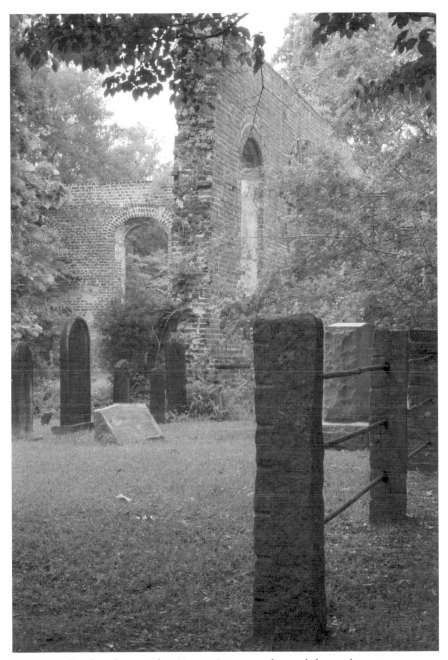

Biggin Hill's church near the Cooper River was burned down three times.

pulled out the letter. This time, the brittle paper held two coins attached with a transparent yellowish wax. The letter informed him that his prayer had been heard. "That night," it said, "the Spirit saw you when passing by your window." The letter asked that he place one coin in his left shoe for his blessings past, and one in his right shoe for blessings to come. The past and present are about to merge, it read, and by keeping the coins in his shoes he was showing his faith. The last line read, "Jesus is watching you outside your door." Skelen pulled the coins away and held them to the light.

The coins had a liberty head on one side surrounded by the words "Confederate States of America 1861." The reverse bore the inscription "1 cent" surrounded by a wreath of corn, cotton, maple, wheat, and tobacco, and two barrels. At the bottom of the wreath lay a cotton bale marked "L." Skelen placed one coin in each of his boots. The letter stated that he needed to pray from the 28th chapter of the Book of Deuteronomy, which was inscribed on the letter, and send his request back in the envelope to Biggin Episcopal Church. It asked that he walk around the next day with both coins in his shoes. The next night he was to place one inside his door and one outside his door.

Skelen wrote a request for money on the brittle paper, being careful not to tear it with the pen. The next day he walked with the coins in his boots while he worked. He dropped the envelope back in the apartment mail slot, reversing the addresses but not stamping it. That night, he placed one coin outside his apartment door and one inside.

The wind blew hard that night as Skelen tried to sleep. He pulled himself out of bed several times and walked to

his front door, anticipating. The coins stayed where he put them. He bent down to look under the door. He saw the coin outside shining in the hall light. He went back to bed.

The coins remained in their positions inside and outside his door all that week. On Saturday, he saw an advertisement in his junk mail for an antique coin show in Charleston. Skelen kept the ad and picked the coins up off the floor when he went into his apartment.

Skelen took the coins to Charleston and learned that they were rare mint Confederate coins made by Robert Lovett Jr., who was commissioned by the renowned Philadelphia jewelers Bailey and Co. The coins sold at the show for over $5,000 each. Happy with his outcome, he returned to Berkeley and checked his mail religiously for another aged letter from Biggin Church.

Skelen looked forward to and anxiously examined his mail every day for the next month. One day, he waited for the postman. When he appeared, he was tall, dark, and distracted as he hurriedly placed the mail into the complex's slots.

"Do you know where a Biggin Church is?" Skelen asked the man, who turned his back.

"A *friggin'* church? You sure you want to be goin' into the house of the lord with an attitude like that?"

"What? No, *Biggin* Church."

"Biggin Church. Yes. You're practically right on it. Fact, you can cut through those trees right there and get to it around the swamp."

"Right through there?" Skelen pointed toward a path through the trees that led up the hill.

"Right there."

"Do you deliver a lot of mail from Biggin Church?"

The postman stopped what he was doing, turned, and gave Skelen an uncertain grin. "What you talkin' about?" he asked.

"Well, I got these old envelopes sealed with wax in my box the last few months."

"Well, I didn't put them there. Why don't you just go on up the hill and go talk to the good people at Biggin Church yourself?" With that, the postman smiled and left the building.

Skelen walked up the path through the woods and found that it led into an old graveyard. He walked through the heat of the graves toward an old brick wall with long spaces where windows had once been. He looked around for a church, but saw none.

A historical marker was positioned next to a tombstone that read "Charlotte Ravenel, wife of Samuel Gaillard, born May 1844, met her eternal rest July 1889." Skelen read the historical marker, which described the history of the Anglican Church on Biggin Hill. He read of its construction in 1712, the first burning in 1756, and the reconstruction in 1761. He looked at the brick ruins over his shoulder, realizing he was looking at the Biggin Church remains of 1761. He read on and learned of the second burning by British troops during the Revolutionary War in 1781. What he read at the end of the marker shocked him:

Biggin Church was again burned by a forest fire in 1886, around the time of the great earthquake of August 31st. Biggin Church was never to be rebuilt again.

LITTLE MISTRESS CHICKEN
AT STRAWBERRY CHAPEL

*T*here are many ghoulish stories about Strawberry Chapel on the Cooper River. It is the only remaining intact building from the vanished 18th century town of Childbury, a place once bustling with life until its residents were killed off by malaria. The only surviving documented story about Childbury relates the frightening experience of a seven-year-old girl who was tied to a tombstone by her schoolteacher and left all night in the chapel's moss-draped graveyard.

Catherine Chicken, the granddaughter of James Child, who founded the town along with French Huguenots in 1707, was sent to board with Monsieur Dutarque while attending school in Childbury in 1748. Her widowed mother had married Elias Ball of Kensington Plantation and had sent her to board there while she raised her second child.

The seven year-old Mistress Chicken became homesick for her mother and for plantation life. One day she wandered away from the schoolmaster's house in hope of finding her way home.

Because Catherine was a member of the prestigious Ball family, Dutarque was overcome with fear of retribution when he realized she was missing. She had walked through Strawberry Chapel and along the docks on the river hoping for a view high enough to see her family house in Kensington. When the schoolmaster saw the child wandering near one

of the streets beside the Cooper River, he asked her why she had run away. The seven-year-old replied that she wanted to be outdoors. Monsieur Dutarque was so angry with her that he told her he was going to give her the outdoors as punishment. He tied her to a gravestone in the village burying ground next to Strawberry Chapel and left her for the night.

The story of Catherine Chicken is the foundation of Mrs. Gordon Rose's book *Little Mistress Chicken*. In her book, Rose records the experience of the girl and her French schoolmaster beside Strawberry Chapel:

> I doubt if he had formed any definite plan of punishment, but a diabolical idea suddenly occurred to him. Perhaps he meant only to frighten her for a while. Perhaps he was really half-insane from the moment, carried away by the tumult of his anger.
>
> Perhaps if she had cried out he might have paused and considered what he was doing, and fear might have prevented him from going on. But little Catherine was limp and white in his grasp, and uttered only a frightened moan, which he found intensely exasperating.
>
> So, in the shadow of the locust-trees, so full of fragrance and the humming of bees, he tied Catherine tightly with her back against a tombstone, her hands behind her and her shoulders strained back with cruel knots.

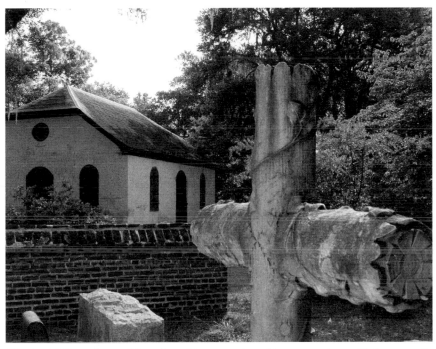

The 1725 Strawberry Chapel and its centuries-old graveyard are all that remain of the vanished town of Childsbury.

"V'la!" he said, pausing to look at his work. "You s'all haf yo' outdoors! And ven you s'all be fatigue, you may call. Maybe I come."

Catherine Chicken remained tied tightly to the gravestone that night until one of the Strawberry Plantation slaves heard her calling. The slave walked through the village burial grounds, holding a wooden gourd-face he had made, lit with a candle. He had planned to use the mask to frighten off any natives or beasts in the forests, not knowing that the white appearance of a child-ghost tied to a grave would in turn scare him.

He found her cold and unconscious. Under the risk of being whipped by cowhide for having left the grounds without a pass, the slave went back to notify his master.

After the discovery of the abuse of Catherine Chicken, the French schoolmaster was drummed out of Childbury. Catherine Chicken lived, but her face and eyes remained drawn to the side as seen in a family portrait when she became Mrs. Benjamin Simmons of Middleburg Plantation. It was the same drawn look with eyes shut that had molded in fright in the Strawberry Chapel graveyard that night in May of 1748.

When her time had passed, she was buried at nearby Pompei Hill. Local folklore has it that her spirit returns to the place where her life was scarred by the cruel act of the schoolmaster. The sobbing of a tortured child is said to continue

through warm spring nights in the village burial grounds beside the old Strawberry Chapel.

Interest in Strawberry Chapel's history rose when its silver communion chalices and plates were found in December 1946 under the rice barn on nearby Comingtee Plantation. The silver had been buried in a mahogany chest in February 1865, when Union General Sherman's raiders were expected to invade the area by gunboats on the Cooper River. After the soldiers had gone, Keating Ball, who had buried the silver, was unable to locate it.

Included with the Strawberry Chapel communion silver were a tankard, paten, and chalice said to have been given to the chapel by King George I. Also found were a silver-gilt chalice, believed to be one of the few brought to the country by French Huguenots, and two offertory plates.

Strawberry Chapel was one of four chapels of ease built in St. John's Berkeley for the convenience of people who lived on plantations far away from Biggin Hill, where the mother church of the parish stood. To attend services at Strawberry Chapel, most members arrived with the tide, often aboard a ferry known as the Strawberry ferry.

The little chapel still stands, empty but intact. It is locked and shuttered except for four Sundays a year when services are held there. Inside, the white-washed walls are bare. Though the elegant wineglass pulpit and oak pews were destroyed in the great earthquake of 1886, the original floor remains where Little Mistress Chicken wandered.

BLOOD IN THE WATER

*T*he day after final exams for Monsieur Dutarque's French class at the Walnut School for Boys in Camden, 14 students arrived from their respective plantation homes to find their teacher absent. They stepped into the wide cabin, placed their books down, and walked to their desks. The boys waited in silence for half an hour for their teacher to arrive, but he never came.

The sound of liquid slowly falling drop by drop onto the wood floor broke the stillness. One of the boys in the front row looked up at Dutarque's desk and screamed, "Blood!"

The boys rushed to the desk and found a thick bloody pool next to a neat stack of their final exams from the day before. The eldest and bravest of the boys, Jonathan Charles Fort, lifted his exam from the top of the stack. Every answer on Fort's exam was marked over with a red X—in blood. At the top of the paper was the grade, F. He lifted the stack up, carefully avoiding touching the thick, dark pool. He began handing the exams out to the other students. Every exam was exactly the same. They were all scored with crimson X's and F's. The students noticed that the graded papers were still slightly wet.

Monsieur Dutarque was hired to teach French for one year at the Walnut School. He found refuge in this inland town of cattle drovers and farmers in the Piedmont region

of the Carolinas the summer after being drummed out of Childsbury for the severity of his disciplinary tactics there. The plantation residents of Middleburg, Mullberry, and Scottsdale were eager to obtain a French teacher for their young men, and Dutarque carried a letter of recommendation with him. It was an outdated letter from the school he had taught at years ago in New Orleans—and from which he had secretly snipped away the date. For most of the school year, neither the students nor their parents knew what cruel intentions lay behind the French teacher's coal-black eyes.

Through the fall and winter, Monsieur Dutarque fluctuated between austere teaching in the classroom and friendly conversation on the school grounds. The 14 boys found him intriguing and asked him many questions about his background and how he got to the colonies. When the questions grew too personal for the teacher, he asked his students to rephrase their inquiries in French. This stopped conversations short since most of the students had only a limited knowledge of the language, which they had gathered from some of the Huguenots from the outlying farms around town.

By spring, the teacher began to limit conversation with his students even more, asking that they only speak to him in French. The parents and headmaster thought this rule was a brilliant way to enhance the boys' language skills. Yet Dutarque continued to speak to the boys in English whenever he pleased.

At the school's drinking well, where the boys congregated during lunch, Dutarque would stop to pull the bucket up for a drink. With a metal cup in hand, he would dip into the water and drink quickly. He usually drank three to four

cups before motioning for one of the students to lower the bucket back down for him. One of the students would obsequiously obey, lowering the rope while watching the wooden bucket slowly disappear into the cold darkness at the bottom of the well.

It was during these visits to the well that Monsieur Dutarque would engage the boys. There was little about the students that he would not criticize—in English. He commented on how unsophisticated their clothes were, from their shoes to their collars and hats. He pointed out the blandness of the food they ate, and the savage manners they had in consuming it. He even went as far as to comment on the boys' families, and how their plantations were less profitable with fewer slaves than the wealthy French plantations of Charlestown and Port Royal. As he spoke, he would at times shake a colorful, beaded bracelet on his wrist while he stared down at each of them.

In the weeks leading up to the final exam, Dutarque became dark and foreboding and the boys turned and grimaced when he approached. But out of respect and a sense of obligation they stayed at the well, allowing themselves to be trapped at length by his chiding. The students wondered if it was a broken heart that had made the Frenchman like this, or perhaps the harsh memories of the conflict that had caused him to flee from his own country. Many believed he had a chronic weakness for red wine, and came to the well to replenish himself after a long night's binge.

Monsieur Dutarque's disappearance remained a mystery for the entire summer. French was not offered the following year, despite several Huguenot farmers' offers to replace the

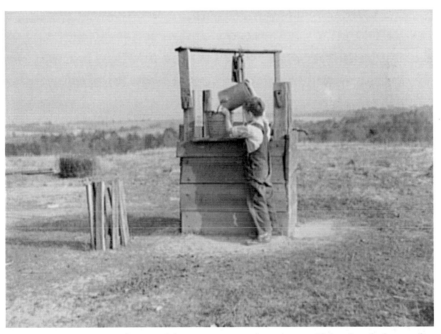

Monsieur Dutarque drowned his sorrows in the same well he drank from after failing all the young students in his French class in Camden.

missing teacher. The cabin where he had taught was boarded up and eventually set on fire by an anonymous arsonist the following fall.

As a new school year began, the students who had not moved on to university crowded around the well to socialize with the newcomers. As one of the students attempted to pull the bucket up from the bottom of the well for the first time that year, the rope barely moved. The older boys figured that the wheels that held the rope over the top of the well were rusted from lack of use over the summer.

Two of the strongest tugged on the rope, until eventually the wheels began to squeak and turn. The boys sweated in the September sun. The rope started to move, but the task did not get any easier. They struggled until a third boy grabbed the rope and pulled as well. Eventually they saw something coming up from the darkness at the bottom. Another boy assisted them and finally, the bucket reached the top.

The boys paused long enough only to hook the rope to the side of the well before scattering away. A gruesome skeleton lay on top of the slowly swaying bucket, its jaw wide open and patches of black hair still clinging to the skull. Its long dangling arms moved slowly with the motion of the swaying bucket. On the wet, white left wrist of the skeleton was a colorful beaded bracelet.

HAUNTED PLANTATIONS

Ghosts of Slavery
and
Legends of the Cotton Kingdoms

PART II

Ghosts of Slavery

The Igbo Tribe Landing

A Charleston-bound slave ship sailed at night into an inlet just south of Savannah for shelter from a passing tropical storm in 1803. The enslaved men and women chained inside were of the Igbo tribe of West Africa, from an area that is now Nigeria. Bandit traders from a rival tribe had captured the Igbo in a raid two weeks earlier. They were delivered in shackles to the departing slave ship in exchange for European gold.

The vessel anchored near Saint Simons Island, Georgia, as gale winds and torrential rain beat upon the wooden deck. Inside the ship's hull, the Igbo tribe's chieftain lifted his heavy chains. The man realized the horror of his fate and broke into a deep, piercing cry.

The chieftain sang an ancestral song known only to the Igbo themselves. The powerful song called on the great water spirit, *Mami Wata*, to take the tribe back across the ocean to their loved ones: "Mami Wata carry us here, Mami Wata carry us back!" As the tribe joined in the song, the eye of the storm passed overhead.

An eerie stillness settled on the windswept islands. Stars appeared, and a full moon broke through the dissipating clouds and lit the deck. The tribe dragged its shackles and chains out from the belly of the slave ship and walked out into the strange, pale moonlight.

The European captain and his mates watched in disbelief as the tribe members wrapped their arms together. The

chieftain looked back directly into the captain's eyes and then stepped backwards over the edge of the ship. He pulled the two women next to him down with him into the cold deep creek and the rest of the tribe plunged in, one after the other.

Those resisting were carried over by the weight of those falling. Their chains ran quickly off the edge of the ship in a grating rattle. The metallic noise of the chains scraping the side of the ship, along with the Igbo's horrific cries and powerful song, echoed across the islands. When the last of them disappeared into the creek, a grave silence encircled the ship. The water eventually stilled.

The Igbo tribe chose mass suicide over a life of slavery. Sea Island legends reveal that enslaved Africans held onto the belief that there is life after death: death was a journey into the spirit world, not an end of life.

Water and the spirit world have always held special significance to many Africans such as the Igbo nation, who today are estimated at around 40 million people. Slave cemeteries on Lowcountry plantations are often found close to bodies of water, since it is water that acts as the passage to the next life. Mami Wata as it exists today represents an amalgamation of many different African water gods.

The enslaved from West Central Africa brought their water-spirit beliefs with them to the new world, and traders carried similar beliefs with them from Senegal to as far as Zambia. Mami Wata beliefs are still present in over 20 African nations today.

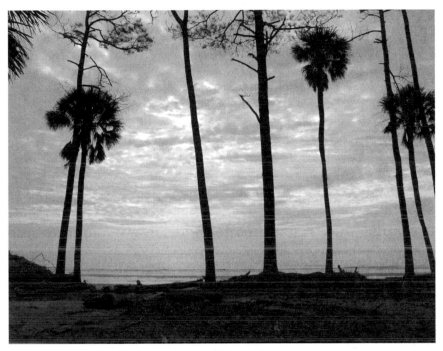

The Igbo people's journey ended off this stretch of Lowcountry coast near Saint Simons Island in Georgia, witnessed by their water spirit Mami Wata.

These water spirits are known to grant favors to those who solicit their help in song or prayer. However, Mami Wata can also extend wrath in the form of tropical storms, torrential rains, floods, and lightning. And if their rules are violated, Mami Wata are known to take the lives of offending humans as sacrifice.

Early Europeans once called the Igbo "savages." However, books by ex-slaves, such as Olauda Ekwuano, reveal that the people who were enslaved were spiritual and highly intelligent. There was very little that the Europeans could trade with the Igbo that the Igbo could not already produce for themselves. They transformed thousands of acres of coastal swampland and tropical forests along the Niger River into tillable fields. Their land was holy ground where the dead and unborn were always present in their daily lives.

That night long ago near Saint Simons Island, the dark water began to move again after the Igbo had disappeared. The full moon disappeared behind the thick shadows of returning storm clouds. The men aboard the slave ship lost all visibility. Palmetto trees and pines began to bend. Winds picked up at alarming speeds.

A tidal surge from the ocean advanced over the marshes towards the ship. The captain and his men quickly huddled inside the hull where the Igbo had been shackled. The sickening air smelled of the prisoners' sweat, blood, tears, and bodily waste.

Dense waves broke through planks on one side of the ship. The surge ripped the metal anchors out of the mud.

Water broke fast into the hull. Creaking boards bent with pressure until they snapped.

The water carried the shattered vessel across the creek. The large masts came crashing down. The slave ship smashed into the sharp edge of a monstrous oyster bed, shredding the vessel and the crew as they bled into the black tide. The ship disintegrated into the saltwater, and the last of the remains of the crew followed where the Igbo had dared to enter first.

According to local mariners, some residents, and shrimpers working the coastal islands of Georgia, the sounds of clinking metal, as well as the Igbo tribe's powerful song, can still be heard around the Lowcountry islands on still nights when the moon is full. The cause of this persistent sound is unknown. Perhaps it is some lingering energy or emotion from the tribe's death, or it could be the celestial voices of Mami Wata taking the Igbo back to mother Africa.

STONO RIVER SLAVE REBELLION

A bloody sun rose over the Stono River on the morning of September 9, 1739. Eighteen runaway slaves met at the center of a bridge in the red dawn, 20 miles southwest of Charlestown, South Carolina. Led by a Congolese man named Jemmy, they had broken into Hutcheson's firearms store early that morning where they brutally executed the shopkeepers inside and seized all of the guns, ammunition, and alcohol. They burned the store down and marched south beside the river. The escapees pounded drums and held a banner that read LIBERTY, shouting the words in unison to all within earshot.

As the mob's drumming and cries were heard, more slaves deserted their masters' plantations to join in. The rebellion's numbers grew fast, and they raided selected shops and plantations along their path. By mid-morning, they had burned nearly a dozen slave-owners' homes and killed scores of European colonists. They spared the lives of only a handful they deemed to be kind to the enslaved and were vicious to the rest.

Their march continued south towards Savannah, in hopes of eventually reaching Saint Augustine, Florida, where the Spanish were offering freedom for slaves who abandoned the British-controlled Carolinas. Just before noon, the rebellion had grown to nearly a hundred slaves when they stopped to camp in a field near Jacksonboro.

South Carolina Lieutenant Governor William Bull was returning on horseback from a hunting expedition with four of his friends when he came across the rebels. As Bull and his friends drew closer to the camp, they saw them cleaning stolen weapons and consuming pillaged liquor and wines. Bull's party was chased off at once by gunfire and machete-wielding slaves.

Bull fled to rally a group of plantation owners and slaveholders to seek out Jemmy and his groundswell revolution. As the sun slid down and the woods grew darker, Lieutenant Governor Bull returned with a posse of armed planters on horses.

A harrowing massacre ensued. By dusk, over 20 white Carolinians and 40 of the rebels were dead. Many slaves escaped into the woods, remaining at large for months and even years. The rest were either executed in the battle or cornered and captured in their inebriation.

The next day, the lieutenant governor reported the Stono rebellion to the British proprietors of the Carolinas:

> My Lords,
> I beg leave to lay before your lordships an account of our affairs, first in the Regards to the Desertion of our Negroes . . . on the 9th of September last Night a great number of our Negroes Arose in Rebellion, broke open a Store where they got arms, killed twenty one White persons, and were marching the morning in a Daring manner out of the Province, killing all they met and burning several Houses as they passed along the Road. I was returning from Granville County with four

Gentlemen and met these rebels at eleven o'clock in the forenoon and fortunately discerned the approaching danger time enough to avoid it, and to give notice to the Militia who on the Occasion behaved with so much expedition and bravery. As by four o'clock the same day to come up with them and killed and took so many as put a stop to any further mischief at the time, forty four of them have been killed and Executed, some few yet remain concealed in the Woods expecting the same fate, seem desperate. . . .

It was the Opinion of His Majesty's Council with several other Gentlemen that one of the most effectual means that could be used at present to prevent such desertion of our Negroes is to encourage some Indians by a suitable reward to pursue and if possible to bring back the Deserters, and while the Indians are thus employed they would be in the way ready to intercept others that might attempt to follow and I have sent for the Chiefs of the Chickasawas living at New Windsor and the Catawbaw Indians for that purpose.

My Lords,
Your Lordships Most Obedient
and Most humble Servant
Wm Bull

The Stono Rebellion resulted in a 10-year moratorium on slave imports through Charlestown. Harsher slave codes had already been proposed before Jemmy organized his

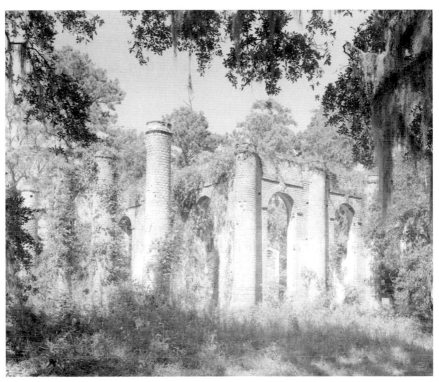

South Carolina Lieutenant Governor William Bull built Sheldon Church on the route of his favorite hunting expeditions. Jemmy and the Stono River slaves marched through this wooded area after burning down a riverfront store in 1739.

revolt. On September 29, 1739, twenty days before the Stono rebellion, the Security Act of 1739 was set to take effect. The law was to require all white males to carry arms on Sundays to guard against slave uprisings. Jemmy was a literate slave and was aware of the Security Act. He and the other slaves may have realized that if they did not act to disrupt the slave system before the law was enforced, they may have never had another chance for freedom.

The revolt led to legal and social changes in the South Carolina slave system. The Negro Act of 1740 was passed, which reclassified slaves as "chattel." The Negro Act made it illegal to teach slaves how to read or write.

South Carolina was a black majority at the time. The fear of further slave rebellions was so great that white freedoms were restricted as well after the Stono rebellion. Slave owners could no longer free their slaves. Taxes were raised on the purchase of slaves to discourage their import, to slow down the growth of the slave population.

William Bull remained in the area, having made the Lowcountry his home. Several years after the Stono rebellion he helped establish the Church of Prince William's Parish near the woods of his favorite hunting expeditions. He was dead and buried beneath a slab at the church by the time the seeds of revolution—planted during his encounter with Jemmy in 1739—grew into something much larger. He likely never imagined a future in which Jemmy and his rebels' vision of liberty might come true, but in trying to suppress his greatest fears through stricter laws he inadvertently helped to create that very future.

The British burned Bull's church in 1780 during the Revolutionary War, but it was reconstructed and renamed

Sheldon Church. In 1861, Confederate General Robert E. Lee walked through the church with his men. Four years later, Union General William Tecumseh Sherman burned the church, once again, on his fiery march through South Carolina during the Civil War. As the flames roared over Bull's grave, perhaps there were still lingering memories of a brutal day in September 1739.

The day after the Stono rebellion, Bull had many of the captured slaves lined up at the steps of their plantation houses. He sent a harsh warning to slaves who were watching. With the rebels bound before their masters' mansions, he called them out one at a time. Bull held a long sword before the trembling runaways. In broad daylight, and in full view of the other plantation slaves, each African who took part in the Stono rebellion was decapitated.

THE LIGHTWOOD COWBOYS

*I*n the deep woods beside the Wappoo Creek on James Island in South Carolina is the obscure slave cemetery of the McLeod and Lightwood Plantations. There are no grave markers, tombs, or even borders to help determine the exact locations of the remains of generations of deceased slaves. All that is known is that hundreds were buried along the Wappoo Creek next to the landing where beef and cotton were loaded onto ships from the plantation.

Once there was a fire station at the bottom of the hill leading to the Wappoo Creek drawbridge, but it burned down at the turn of the 21st century. One October evening, the year before it burned, two firemen saw four dark-skinned men on horses in the woods at twilight. The firemen stepped into the heavy underbrush of the woods to get a closer look.

The woods appeared too thick to allow horses to pass through the trees, but the men advanced all the same, appearing as dark blurs in the shadows of the trees and setting sun. As the firemen walked deeper into the forest, the horsemen suddenly appeared on their other side, between where they now stood and the silhouette of their firehouse. According to their accounts, the four horsemen seemed to drift by with no sound of twigs cracking, leaves rustling, or any other sound of movement at all. Before the firemen could get a clearer view of them, they had vanished.

They proceeded further into the woods, looking for the horsemen, but soon had to retreat when the thickness of the waist-high, thorny underbrush and the close proximity of the trees made it impossible for them to go any further. They had to use pocketknives to cut their way back out.

The firemen returned to the woods several times on separate evenings but did not see the four men on horses again until late the next spring.

The land now referred to as McLeod Plantation originated in 1696 along the Wappoo and Stono Rivers on James Island. The property began as a little over 600 acres owned by Morris Morgan. There were few buildings except for slave quarters in the beginning, as most plantation owners during the colonial period lived in other places, away from their slaves. Until the 20th century, most James Island residents were of West African descent.

James Island was one of the unique places in the Lowcountry plantation system where cotton was not king. The main staple for the Lightwood Plantation was raising cattle. Slaves rode horses while herding the livestock away from the marshes and creeks. Most historians agree that the slaves of James Island were the first American cowboys.

The Lightwood family bought the plantation along Wappoo Creek in 1770 and constructed a plantation house on the land; at this point it consisted of over 900 acres. In 1853, William Wallace McLeod bought it. The Lightwood house was burned in a fire and McLeod built the current plantation house around 1853. However, the five remaining wooden slave cabins, the dairy, and the kitchen building

are believed to date back to the Lightwood period, possibly built as early as 1770. The old slave bell from the Lightwood era, used to call slaves in from the fields, still hangs from the giant oak tree by the McLeod Plantation house.

The land increased to over 1,600 acres during the McLeod era, which lasted until 1990 when Willis Ellis McLeod died at age 105.

The McLeods continued to sell and rent properties to African Americans long after the Civil War. Many of those who rented the former slave quarters up to the turn of the 20th century were descendents of the McLeod slaves. At the start of the Civil War in 1861, William Wallace McLeod owned around 75 slaves and 26 slave cabins on the plantation, according to the Friends of McLeod organization.

McLeod served in the Civil War and moved his family to Greenwood, South Carolina. He left a slave named Steven Forrest in charge of the plantation. Forrest received news in 1864 that McLeod had been killed in the war. McLeod's wife died soon after, and all that was left of the McLeod family were a teenage son and two young daughters. Federal troops stormed the vulnerable James Island plantation and the house was used as a Union army headquarters. The house became a hospital for black soldiers from the 54th and 55th Massachusetts. The drawing room served as the operating room, and those who died were buried in the slave graveyard behind the old James Island firehouse beside the Wappoo Creek.

After the war, the McLeod plantation cowboys took their horses elsewhere around the island. The plantation became populated with the pine bough shelters of hundreds of freed slaves. The house became a local office of the Freedman's Bureau

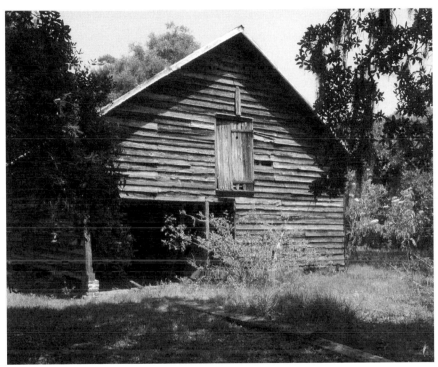

The barn at the McLeod Plantation. The slaves who managed the cattle around James Island were called "cowboys," making them the first in America. Centuries later, they still ride through their ancestral cemeteries along the Wappoo River.

and freed slaves from all over James Island camped there to be within hand's reach of free rations and their promised "40 acres and a mule." But by 1879, the Federal occupation was over and congress had failed to pass the act that would have delivered on the promise. McLeod Jr. had to fight his way through crowds of angry blacks to claim his plantation.

William Ellis McLeod, who passed away in 1990, requested in his will that the plantation be opened to the public. After extensive renovations to protect the integrity of the original property, the Historic Charleston Foundation and the School for the Building Arts are responsible for opening the property to the public in order to honor the last survivor of the plantation era's dying wish.

Back at the turn of the 20th century, spring had come to the old fire station at the bottom of the hill. The two firemen who had seen the four cowboys the past October entered the woods by Wappoo Creek again. In an attempt to find some of the old plots of the slave cemetery, they carried a metal detector with them.

The sun was dropping behind the McLeod plantation house. The firemen walked through the forest by the old landing once used to haul produce down to the water. Though still haunted by the image of the four men, the firemen did not expect to see them a second time.

But at the edge of the woods, in the shadows stretching across the water, the ghosts appeared again. This time, they were not moving.

The firemen grew silent. They advanced along the side of the woods toward the ghosts. When they got within 50

yards, they could see that the horsemen were in no way physical. One of them had part of an oak tree running straight through the back of his horse, as if the trunk had grown through the animal. Another cowboy's dark face was translucent, allowing the firemen to see the side of the Wappoo drawbridge through it. The other two appeared to be rippling in dark rhythms as if they were mourning flags at the edge of the creek.

As the fiery orange sun set behind the plantation fields, the firemen attempted to move even closer to the horsemen. But in the growing shadows of the trees, the images faded slowly away.

Voodoo in the Holy City

*G*ullah is an entire culture transplanted from Africa, filtered through the Caribbean islands through slavery, and mixed with a veritable grab bag of cultures from the people who settled along the South Carolina coast. When people think of Gullah, they often hear the rich, melodious rhythms of the language. It is an eclectic blend of French, King's English, vernacular English, various Caribbean dialects, and native African languages. Sometimes the spoken language of Gullah is unintelligible to a confused new listener—gender and number, for example, often are not factors in this fast-paced patois.

But it is the superstitions of this rich culture that fascinate those interested in the murky, mysterious realms of the supernatural. Minutes out of downtown Charleston lies John's Island, South Carolina. A turn down any dirt road will reveal homes, some no more than shanties, painted an alarming shade of blue. It is a rich, gaudy blue, like that found on a handicapped parking sign. Ask a local what that color is and they will tell you it is "haint blue."

Haint blue is used in the Gullah culture of the Lowcountry to physically ward off the advances of haints, or haunts, which are not ghosts but physical, half-living zombies. While some interpretations describe the haint as more of a disembodied lost soul, like some of the spirits described elsewhere in this book, the most common image of a haint resembles the

stereotypical description of a voodoo zombie, a wide-eyed, catatonic stalker moving like an automaton unaware of its surroundings. In the Lowcountry, these entities can be as capricious and vague as breezes blowing under the door to things far more tangible and terrifying.

Many houses in and around Charleston, not just on the back roads of John's Island, have shutters, or the front door, or even the whole house painted haint blue. There is an ancient symbolic quality to the color. The tomb of King David is shaded this color, and it predominates superstition in Islamic societies. Whether hanging as a bottle in a withered graveyard oak, or slathered on a front door, the color is believed to keep out evil, whether in the form of a haint or otherwise.

There is an old belief from across the Atlantic that evil will not cross over water. Perhaps this shade of blue is representative of the eternal body of water. Ironic, considering that many who live this culture are descended from people who came across the ocean shackled in ships sailing on winds of greed and piloted by men blind to any good in humanity.

Denmark Vesey crossed that ocean before coming to Charleston, but his role was not that of hunter, but of captured prey. He worked in the cabin of a vessel owned and captained by a man named Joseph Vesey. In the course of their travels, they visited Santo Domingo, Haiti.

In that world of heat and anger, the young slave Denmark Vesey would have seen firsthand the mysticism of voodoo, a blend of African religious beliefs with various other cultures

that merged in the name of planter wealth. Despite different shades of skin and tone of tongue, these enslaved humans were united by cruelty, bonded in the dark practices of the old world and their hatred of this new world.

Denmark Vesey earned his freedom in his early 30s via the Charleston City Lottery on King Street. He bought his freedom from Joseph Vesey in 1799 and lived fairly well off on Bull Street. However, he was so bitter about having been a slave in his youth that he spent much of his time studying the Haitian revolution. He also frequently emphasized the plight of the Israelites escaping Egyptian bondage as related in the Old Testament during his time as a lay reader in the African Methodist Episcopal church.

It was during this time that Montserrat, the great Caribbean volcano, created the 1822 "year of no spring" in Charleston. As warm air rose from lower latitudes, the Carolina skies clouded with volcanic ash, enveloping the city in a perpetual eclipse. In this shadowy setting Denmark Vesey and an African priest from Mozambique known as "Gullah Jack" Pritchard were accused of plotting a heinous slave revolution that would have killed every man, woman, and child residing in the immediate area.

Gullah Jack is commonly referred to as a witch doctor. He embodied the secrets of voodoo mysticism and was known to bite the heads off live chickens in ceremonies. As the warm blood flowed into his belly, he hoped to have visions of the supernatural. It is probable that a fever from salmonella poisoning could have induced visions for the man. Along with his belief in haints, Gullah Jack also believed that if he carried a blue crab claw between his teeth it would make him impervious to the white man's bullets.

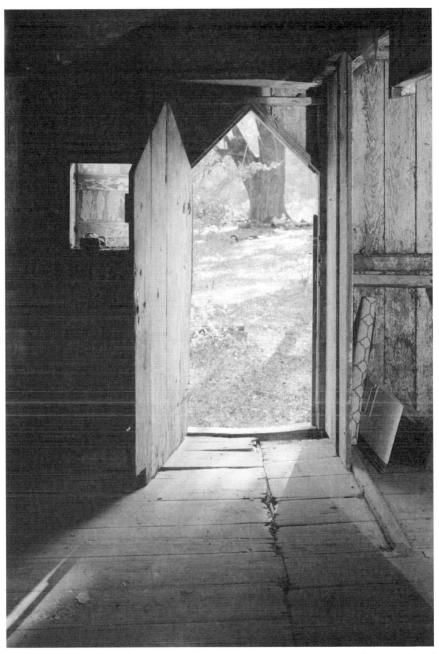

The burning of black holy sites during the South's fear of slave gatherings forced the voudon religion underground, where it flourished in slave cabins like this.

Trial records do not conclusively prove the guilt of Gullah Jack or Denmark Vesey, and they died denying involvement. However, on the testimony of two talkative slaves named Peter Poyas and Monday Gel, the two men, along with 33 accused accomplices, were hanged in the area that is now Marion Square. Gullah Jack was executed with a crab claw between his teeth. Apparently, the claw was no help against asphyxiation by hemp rope. Some whites involved with the conspiracy were released but sentenced to a state of perpetual poverty. Hundreds of other coconspirators were transported out of the Charleston city limits.

The A.M.E. church Vesey worshiped in, the second oldest in the world, was burnt to the ground along with all other A.M.E. churches in the city's state of paranoia after the alleged slave revolt. Many installed chevaux-de-frise spiked ironwork to guard their homes from imagined intruders. Much of it was melted down to use as Confederate cannonballs during the Civil War, though it still crowns brick walls around a few downtown homes.

The burning of churches accelerated racial tension in Charleston, as enslaved Africans took seats in the balconies of European churches. Vesey's church was eventually rebuilt in 1867, and its tall steeple stands to the north of Marion Square today.

In the same area near the site of the executions is the city fortress built in response to Denmark Vesey and Gullah Jack, the Citadel. This building, and the Military Institute of South Carolina itself, exist as a response to the alleged slave revolt of 1822. The Citadel campus has since moved and a hotel now occupies the

old fortress, but the area remains the eternal stalking ground of two of the Lowcountry's most misunderstood historical figures.

There have been scientific investigations into the practice of zombification in the voodoo world. Wade Davis, an ethno-botanist from Harvard, went in search of the science behind this fantastical nightmare of the risen dead in the 1980s. In his research, he concluded that voodoo witch doctors enslaved people by turning them into entranced zombies.

Using an ointment derived from exotic flora and grim, deceased fauna, a voodoo shaman could create a semblance of death undetectable by even modern medical authorities. The one ingredient that had true power to lower the metabolism into a state of death-mimicry was the poison of the fugu, or Japanese blowfish.

In Japan, fugu is a delicacy with addictive appeal. Only chefs specially trained and licensed can create this culinary oddity. The right amount of the toxin creates a sense of ecstasy, complete with tingling sensations throughout the body and euphoria well after ingestion. Too much of the toxin, however, can cause disaster.

Davis noted many incidents where Japanese diners went into deep comas or even perished after ingesting too much of the toxin. Several cases involved people waking from a paralyzed state as their bodies were being prepared for burial. In both Haiti and Japan, some people were released from this deep trance while already in the coffin, a nightmare scenario for most mortals.

The fear of meeting someone in this state, or worse, being turned into an actual zombie, is the basis for the need for spiritual protection at all costs among people of the Haitian culture. A stark blue color or quirky custom that might seem strange or tacky to the uninitiated visitor may be as serious as a quadratic equation or pacemaker to the descendants of Gullah culture.

THE SAVANNAH SLAVE SHIP

*F*or years, an unexplainable pull has been felt on the port side of the hulls of boats rounding the north bend of the harbor of Savannah, Georgia. The powerful force has affected the navigation of outgoing vessels almost to the point of disaster, and voices, thought to be Congolese and French, have been heard rising through the pulling current in the brown water. Some old mariners have attributed this to the story of a French slave ship known as the *Grietley*. The incidents began in the 1940s after the last surviving slave of Kensington Plantation, Mason Greenley, died.

On the August evening in 1854 when the *Grietley* entered Savannah, the harbor resembled a dark sheet of glass, according to local mariners. The two-ton slave ship had come to Savannah to purchase 71 mostly Congolese captured runaways and other unwanted slaves from the Fairfield, Lawshe, and Ragsdale Plantations. American law had completely forbidden the international sale of slaves by 1820, but the *Grietley* was a notorious pirate slaver. The crew purchased slaves within the United States and then transported them to any number of places, from the Caribbean islands to countries as far away as Brazil.

On this occasion the ship stopped in Savannah for two days while the failed escapees and other exiled slaves were

handed over to the roughnecks of the *Grietley*. During this exchange, the stronger of the Congolese had time to gather their strength and plot another attempt at freedom.

Upon leaving the docks, the crew allowed the ship to drift with the current toward the entrance channel. Many of the slaves were shackled; however, with so many aboard, the crew had to rely upon ropes to restrain some for lack of enough chain. Dozens of slaves were simply standing on deck with only their hands tied and many managed to get loose of their ropes and jump overboard to rejoin the local population in Savannah. As the crew saw what was happening, they fired shots into the water where Congolese men were swimming toward the shore.

Unfortunately for the Frenchmen, other slaves deep in the hold had loosened their ropes as well and had kicked out some of the boards that held the ship's frame together on the starboard side. The ship began to sink directly over one of the only holes deeper than the entrance channel, the turning basin for steamships carrying cotton in the days before the Savannah bridge. Local tugboat operators offered help, but the French captain refused until it was too late. The ship soon disappeared beneath the water of Savannah's harbor.

The *Grietley* was raised by U.S. authorities and taken to a Savannah boat yard where it was converted into a barge for carrying produce from the plantations to the city. The crew members were interred in Beaufort, South Carolina.

Some lingering vestige of the incredible energy expended by the slaves in their desperate bid for freedom from the

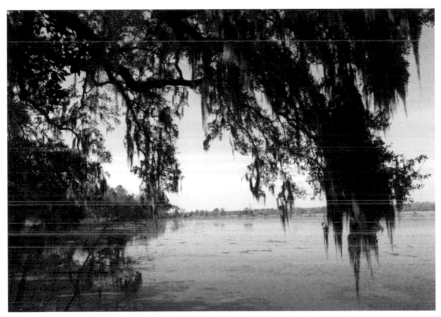

After slavery was abolished in the United States, international crews continued to trade slaves on the East Coast in the form of piracy. The ghastly incident in Savannah's harbor took place near this quiet stretch of water.

doomed ship may still lurk in the waters of Savannah, or perhaps the rage of the French crew, disappointed in their heartless quest for easy profit, survives somehow despite the men's deaths. Perhaps these ghosts don't know they are dead or that the days of slavery and cotton kingdoms have ended. Yet again, their reason for haunting the harbor and trying to pull other ships down to share their cold fate may be darker still, and forever inexplicable.

SUNSET AT BOONE HALL BRICKYARD

*N*ear Wampancheone Creek and the ruins of a 19th century brick kiln chimney, appears the startling image of a woman standing in the grass on the side of the road. The woman moves her hands close together in repetitive, spastic thrusts as if in a trance. She is dressed in ragged, dark clothes. Her face is unclear, tilted down toward her jerking hands and masked by long, straw-like hair.

The woman has only been seen at dusk. The longer the sunset, the more pale light passes through her image, revealing that she is not of this world. All the sightings have occurred within 20 yards of one another. Because of her proximity to the kiln and the creek, she is believed to be the ghost of a slave from an 18th century industrial brickyard. The Wampancheone waterway, on the side of the original Boone Hall plantation, is where creek mud was used to make bricks and tile for much of Charleston, including Boone Hall's slave quarters.

At its peak a decade before the Civil War, the brickyard was estimated to produce four million bricks annually with the labor of slaves from Boone Hall and other local plantations along the Wando River. The soil around Wampancheone Creek contains special clay suited for earthenware and brickwork. The bricks created by the hands of slaves were used

to build many of the churches and homes that stand today in and around Charleston. The old brick kiln chimney near Wampancheone Creek remains as well, as testament to the tremendous amount of labor that took place at the back of Boone Hall.

The brickyard originated as the first large industrial area of Charleston in the suburb of Mount Pleasant in the 1800s. The area was originally named Wampancheone by native tribes before European settlement in the 1600s. The area was then named Christ Church Parish by King Charles II of England when he bestowed it upon colonial settlers known as The First Fleet Society. A corner of the 17,000 acres granted by the King for Christ Church became known as Boone Hall plantation in 1681, named after beneficiary Major John Boone.

When two brothers, John and Henry Horlbeck, bought the plantation in 1817 they converted the back side of the plantation near Wampancheone Creek into the Horlbeck Brickyard. The Horlbecks were involved in building many of the churches and other buildings around Charleston and needed many bricks to help meet the demands of the increasingly prosperous city. The Horlbecks also planted large pecan groves at Boone Hall, a reason why it is one of the last active plantations in America today. The Horlbeck Brickyard quickly evolved from a few kilns used by some of their 225 slaves into a full-scale operation serving the entire Charleston area.

It is perhaps appropriate that the Boone Hall specter is seen near the kiln chimney, moving its hands repeatedly.

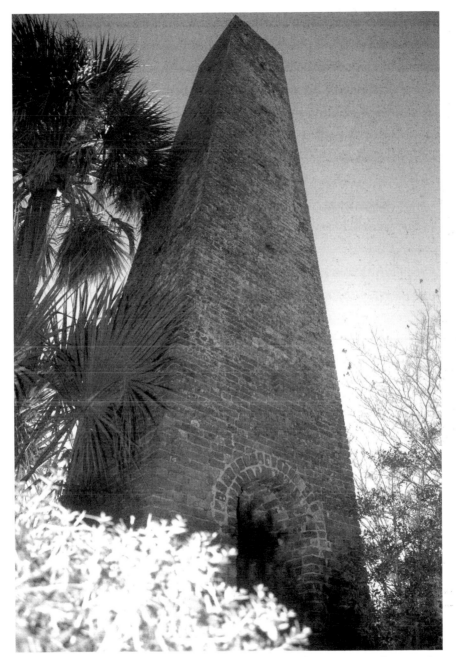

The historic kiln at Boone Hall's brickyard is near where an eerie phantom has been reported standing on the side of the road around sunset.

The efforts put forth by those who worked at the Horlbeck Brickyard behind Boone Hall plantation involved the molding of the Wampancheone Creek mud to make millions of tiles, earthenware, and bricks. The constant repetition of molding the clay may have been what brought this spirit back to the place where she expended so much of her life and her energy. Yet hundreds of slaves worked at the brickyard for many years. What was it about this one that causes her to linger?

Speculation as to the cause of her death could present darker, more tragic possibilities. An inventory of Horlbeck slaves from January 1854 is kept in the manuscript section of the Southern Historical Collections at the University of North Carolina at Chapel Hill, but the records only show the death dates and not the cause of death of a few of the slaves in the Horlbeck Brickyard. While the work was intense and demanded much of the slaves' energy, it was not often dangerous except when the large kilns were lit up to cook the clay.

It was at sunset, the same time Boone Hall's Brickyard phantom appears, that the slaves stopped work and shifted their chores. At this time the day's clay molding was done, and in the shadowy light of dusk the bricks and tiles were put into the kilns. During this process, the appearance of firelight and sunlight could easily become blurred to an exhausted slave like the one who may be replaying her tragic ending at the side of the road near the remains of the kiln. Perhaps she was inside a kiln, laboring over bricks, when she gave in to her exhaustion. At dusk, the kilns were fired to extreme temperatures and left to cook over the course of the night.

RETURN FROM THE BARRACOON

The 1837 Bed and Breakfast in Charleston leaves guest diaries in all its bedrooms. One room with a balcony where a young slave named George resided with his parents in the 19th century has had some unusual entries over the years. For example, in one entry for November 4, 2003, two guests from Michigan record their armoire doors opening and closing throughout the night.

Earlier entries reveal even more startling encounters. A woman from California penned an experience during a hot day in June 1999. Apparently the rocking chair on the balcony outside her room kept rocking quickly back and forth, as if an energetic person was enjoying the rocker for the first time. She was trying to nap after a long day of walking in the still, hot air. She looked out the window and noticed that there was nobody in the chair. Just then, the manger hollered upstairs, "Stop!" and the chair immediately stopped rocking. The guest asked the manager about this strange occurrence but the manager simply replied nonchalantly, "It's just George playing again."

Sometime in the early 1830s, a contractor named Shilling found himself and his team of house builders employed to build a single house at 126 Wentworth Street. Among the deals worked out between Shilling and the owner of the

property was that the family of one of Shilling's slaves would live and work at the new home for one year after completion. After completion, the owner, Mr. Holder, would have the option of buying the family.

When the house neared completion, George and his parents moved into the top floor room on the Wentworth Street side. George was mainly used as a stable hand, washing down Holder's two brown stallions and feeding them daily. Occasionally Holder would send him on errands to shops not far away. George would go to the banks of the Ashley River to play. He found great joy in watching other children, both white and black, frolic in the water.

As time passed, Holder could no longer afford to keep George's mother and father. A rich planter from Virginia offered to buy them both for a large sum of money. A man named Thomas Ryan was hired as a broker at a barracoon, or "slave hotel," on Chalmers Street.

Charleston was one of the great slave-marts of the South. The city statesmen legislated for it and ministers of the gospel upheld it as the best means of Christianizing Africa for the ultimate benefit of the whole human race. A score of men opened up offices in barracoons along State and Chalmers Streets and dealt in the buying and selling of men.

One of the remaining examples of the Charleston barracoons is 6 Chalmers Street, one in the same line of buildings where George's family was sold by Mr. Holder. The "Old Slave Mart" as the inscription on the front of the building still reads, has wooden front doors painted blue in homage to the culture of the people enslaved there.

In many of the barracoons, the buyers interviewed the slaves privately in booths, with the slave broker on hand.

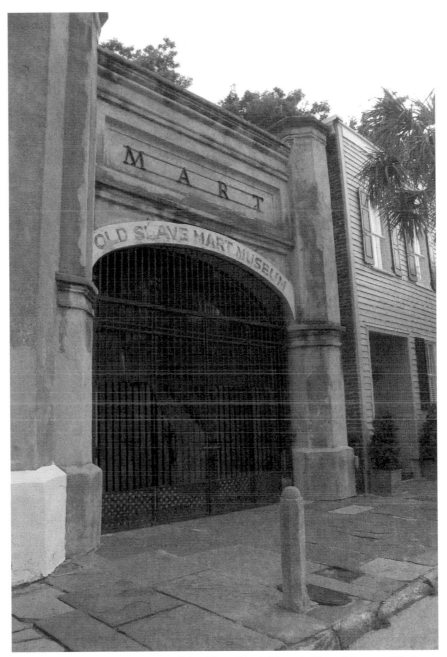

Barracoon is a Portuguese word for "slave hotel." Ryan's Slave Mart on Chalmers Street in downtown Charleston was a barracoon where slaves were traded for many years.

In public auctions, the enslaved men and women were advertised in the city paper three days before the auction. On the day of the bidding, the slave stood on a balcony, far enough away from the bidders so that no imperfections such as scars, cuts, or gray hair were visible.

In the cellars below the barracoons along Chalmers and State Streets, bolts have been found embedded in the floors along with manacles and chains for the hands and feet. Often a man would be in the cellar with the slaves, playing a fiddle and attempting to get the shackled men and women to dance, strengthening their muscles and raising their spirits for the interviews and auctions.

One of the saddest aspects of slavery, besides the blatant inhumane physical and emotional brutality, was when a family was split up. Plantation slaves rarely worried about their families being divided because of the abundant wealth of their owners. However, downtown slaves were subject to the same economic woes of the townspeople.

Mr. Holder brought George's mother and father down to Chalmers Street to be interviewed in one of Mr. Ryan's brokering booths. George watched silently through the open door of the barracoon beside Holder's horse. His parents demonstrated their various skills of weaving and cutting to the Virginia planter.

Within a short while, the Virginia planter shook both Ryan's and Holder's hands. A stack of paper cash and coins was exchanged between the three men and Holder signed the bill of sale on the broker's desk. George's mother and father looked at him through tears as the Virginia planter escorted them out the back doors of the slave barracoon.

George was distraught over losing his parents. He had bad dreams of his parents being shackled and beaten. He tossed in bed the night his parents were to leave until he finally awoke. He fled the safety of 126 Wentworth Street and ran towards King Street, the only way in or out of Charleston by land. There he hoped to catch up with his mother and father.

When George arrived on King Street, he began asking travelers how close he was to Virginia. A wayfarer lifted him up on to his wagon and let George ride in the back. George looked out the back of the wagon for hours looking for his mother and father in Virginia. His eyes eventually grew weary and he nodded off.

The next day, George found himself back in Charleston alone in the cellar of a barracoon. His hands and feet were shackled. The door to the cellar opened and light poured in. Ryan walked in with Holder, who was holding a bullwhip. Ryan unshackled George and Holder threw the boy on his shoulder. George returned to 126 Wentworth Street to work in Holder's stable.

There are little records of George's life after the sale of his parents on Chalmers Street. Despite Charleston being known as the largest slave city in America, slaves were not allowed to read or write—making family records virtually impossible to find.

On November 27, 1997, Dawn and Alex England from Naples, Florida had the closest recorded encounter with the ghost of George. The Englands' entry reads:

Alex and I slept soundly in our warm rice bed all night after eating an enormous Thanksgiving meal of soul food and turkey at Jestine's Kitchen down the street. In the early morning, around six-thirty, both of us jumped up quickly in our bed when we heard the loud, sharp crack of a whip! Neither of us saw anything at first, but then there was barely morning light coming through the window and only a distant streetlight that we saw through the oak trees. I leaned over and turned on the lamp next to the bed and, as I did, we both began sniffing the room because of this overwhelming smell of hay! Alex mentioned the hay smell to me and I agreed. We began looking around the covers for hay grass and, as we did, we both stopped cold. At the end of our bed, at the back of both our covered feet, was the indentation of two little feet! We both leaned over and we then felt the end of the bed quickly bounce! The impression of the feet was still there. We got out of bed and looked around but nothing else happened and the smell of hay quickly went away.

While George's ghost has yet to be seen, his youthful spirit and energy are all around the old slave quarters on the top floor of the house. Despite the apparently tragic ending of George's family, he still comes back to play at 126 Wentworth Street.

THE EXODUS OF MASTER LESESNE

A boat messenger delivered a sealed envelope from New Orleans to the Lesesne Plantation, near Charleston, on Daniel Island, South Carolina, one gray morning in October 1803. The envelope, marked Urgent, was addressed to Master Thomas Lesesne.

Lesesne's house servant cut open the wax seal with a knife, placed the envelope next to his tea on the breakfast table and walked away.

Lesesne glanced out his window, watching field hands moving through the morning fog. When his father was alive, Thomas had watched him whip the slaves if they were not in the fields by sunrise. Thomas Lesesne chose to leave the unpleasant cruelty of plantation discipline to his overseers.

He unfolded the letter, which had been sent to him from his cousin Arnaud. He soon realized it was a warning. A month earlier, his cousin had escaped a violent ambush on his plantation in the French colonies of the Caribbean. Lesesne slowly read over the harrowing details of what his cousin had witnessed in the Caribbean.

The servant entered the room with freshly cleaned silverware, and Lesesne turned the letter to the side so that she could not see the words. His father had not allowed any slave to read or write, but Thomas Lesesne encouraged his house servants to learn to read the Bible. He continued reading the letter when the servant left the room.

In the French plantations of Santo Domingo, Lesesne's cousin, along with the other French plantation owners, had also allowed their slaves to learn to read. They reasoned that the Bible would only help Christianize the more rebellious among them. However, the policy backfired when the island's literate slaves learned of the French *Declaration of the Rights of Man and of the Citizen*, first drafted in the late 18th century.

That revolutionary document declared rights, liberty, and equality to be the basis of all legitimate governments and social systems. The revolution that erupted in France over the document soon spread to the French plantations in the Caribbean. The coffee and sugar plantations on the islands required vast amounts of labor, so the slave populations outnumbered the French plantation owners by terrifying amounts.

Even with the recent American and French Revolutions, the French plantation owners were caught off guard when over 100,000 slaves rose up from beneath them to violently create their own republic, called Haiti. By the force of sheer numbers, and because word could spread quickly among the island's closely-packed plantations, the slaves were able to set up and maintain their own social system, giving them an independence that would have been impossible in the intentionally-scattered plantation communities of the Lowcountry.

During the Haitian Revolution, a carriage driver named Touissant L'Ouverture rose from being a slave to the commanding general. Unlike the American and French Revolutions, the slaves in Haiti didn't desire liberty alone—they wanted vengeance as well. But even while the mass

killing of whites occurred all around General L'Ouverture, he refused to actively participate in the bloodshed that gave the former slaves control over most of the island.

As fire erupted on the plantations, an overwhelming number of ex-slaves brutally executed most of the Europeans that fell upon. Despite these atrocities, L'Ouverture was somehow able to sustain relations with France.

European plantation owners retained the western third of the island, where Lesesne's cousin lived. Until 1803, this third was nominally still under the control of France; for two decades, Lesesne's cousin Arnaud and his family had little disruption in their plantation lives despite the atrocities occurring on the other side of the island.

When one of L'Ouverture's military commanders went mad with power, he acted against his superior's orders and insisted that all the former plantation houses be burned to the ground everywhere on the island. He also commanded that every white man, woman, and child still alive on Santo Domingo be killed immediately to avenge their enslavement.

To make matters worse, Napoleon Bonaparte came into power in France. Aside from not wanting to share power with L'Ouverture, Bonaparte was a notorious racist. He conned L'Ouverture into a meeting with the French in 1803 where he arrested him upon arrival and sent him to a prison in France. L'Ouverture died soon after in April.

Upon the death of L'Ouverture, an angry former slave named Jean-Jacques Dessalines assumed control of the Haitian military. One of the most horrifying struggles between French whites and Haitian blacks took place between Dessalines and Napoleon's government. The

French were instructed to execute every black they came across. Dessalines responded with the command that every atrocity committed by the French must be revisited on the French. Both sides waged war on these murderous, cutthroat terms.

In the Lowcountry, news of the Haitian revolution was an inspiration for American slaves and a source of extreme anxiety for their masters. Guns were stocked in houses and secret shelters were built. Fear became the rule of the times.

Lesesne was aware of the revolution that had been occurring in Haiti since 1791. Like most other plantation owners, he was well aware of the tinderbox Lowcountry whites were sitting on.

An article in the Charleston *State Gazette* on November 22, 1797, sheds light on the fear circulating around the Lowcountry at the time:

> On Tuesday, the 14th, the Intendant received certain information of a conspiracy of several French Negroes to fire the city, and to act here as they had formerly done at Saint Domingo—as the discovery did not implicate more than ten or fifteen persons, and as the information first given was not so complete as to charge all the ringleaders, the Intendant delayed taking any measures for their apprehension until the plan should be more matured, and their guilt more closely ascertained; but the plot having been communicated to persons, on whose secrecy the city magistrates could not depend, they found

themselves obliged on Saturday last to apprehend
a number of negroes.

Lesesne had ignored most of the talk around the Cooper River plantations as unwarranted paranoia. He had avoided calls to keep a closer eye on his slaves with accurate ledgers of their numbers and assigned tasks. He had let his slaves populate as they pleased, seeing their numbers grow rapidly over the past decades since he had inherited the plantation. Lesesne counted the growth in population as a blessing from God: the more slaves, the greater the wealth for his family.

In Charleston, not far from the Lesesne Plantation, a carpenter named Denmark Vesey had earned his freedom by winning a lottery on King Street the same year the Haitian revolution began. He bought his freedom from his master and lived comfortably on Bull Street, downtown. He was a lay reader at a nearby church and kept relations with the people he had met in the Caribbean while traveling to Charleston, long ago. Denmark Vesey lived across the Cooper River, a little more than a mile from Master Lesesne and his family.

Vesey was so bitter about having been a slave in his youth that he became the spokesman for news of the Haitian Revolution. Vesey was seen on Charleston street corners stopping slaves to talk to them. He clasped their slave tags and explained to them the inhumane treatment they tolerated.

Most slaves tried to ignore Vesey, not wanting to get into any trouble with their masters. However, when he brought out a copy of the Bible and read to them about the plight of the Israelites escaping bondage in Egypt, they

were enthralled. Because Vesey was a man of God and could read, many slaves were fascinated by him.

Between 1791—when Vesey was freed—and 1822, he was said to have rallied up to 9,000 slaves for his rebellion. A priest from Mozambique, known as "Gullah" Jack Pritchard, was arrested along with Vesey in connection with the conspiracy. Pritchard was believed to be a voodoo witch doctor, a healer of men, and a sorcerer of black magic. The history of these men is unclear: many accounts of their lives say they were evil men, while others compare them to revolutionary patriots of freedom—men whose histories have been rewritten in order to suppress their cause.

Vesey was accused of planning to duplicate the Haitian Revolution in the Lowcountry, using the power of the slaves he had rallied, along with assistance from the Haitian government, which would send troops on ships. They allegedly planned to coordinate the overthrow of the Lowcountry plantation system in a violent upheaval on June 19, 1822.

Master Lesesne read how fortunate his cousins were, considering the horrific war that pillaged their side of the island in 1803. His cousins remained on good terms with their slaves as they witnessed their neighbors' plantation houses being burned and the families destroyed.

During the genocide, the Lesesne slaves decided to save their French masters from the bloodthirsty revolutionaries. They hid the family inside sugarcane sacks, which they calmly carried over their shoulders onto a cargo ship exporting coffee and sugar to America. The Lesesnes escaped in silence across the Gulf of Mexico to New Orleans.

When the ship arrived, the slaves freed their masters. Once out of harm's way, the family made haste to warn their relatives of the grave dangers of losing control of slave populations.

Master Lesesne read the letter three times before going to his study room to find his plantation ledgers. He pulled out his accounting book and reviewed how many slaves were on the plantation his great-grandfather had established in 1676.

The ledgers had not been updated in 12 years, but the last entries indicated that he had 73 slaves. Master Lesesne had personally seen at least 15 slave births in the past decade and knew that this number was not accurate.

The island where his plantation was located, Daniel Island, was very large. Although Lesesne's family had been one of the first to settle the land while it was still inhabited by the Etiwan Indians in 1676, an Englishman named Robert Daniel had claimed the largest portion of the island in 1740. The Lesesne and Daniel families had little interaction however, since most plantations were situated far apart from one another.

Lesesne had 12 fields producing indigo, cotton, and various other crops. His had four boys and three girls. Though Lesesne never produced offspring with any of his slaves, he was fairly certain that his grandfather and father had relations with many of the female slaves. Three of his eight overseers were light-skinned, and two of them had hazel-blue eyes.

Everyone on Lesesne's plantation spoke French, but some of the older slaves spoke Gullah, a blend of French, English, various Caribbean dialects, and native African

languages. Lesesne relied on his overseers to communicate with them.

That afternoon, Master Lesesne set out to conduct a count of the slaves on his plantation. He took two of his light-skinned overseers, Primus and Friday, with him. His father had originally paid white men to be overseers, but as he grew older, he allowed trusted slaves to occupy the office in order to save on expenses. This was one of the most difficult jobs on the plantation, and it involved, among other things, whipping the other slaves when required.

The three men rode around the fields and to the edges of the property. Within the first half hour, they had already counted over 73 slaves.

On the northwest side of the island, facing Charleston, Lesesne was startled to find a cleared area beside the river. He had not been down to this part of the plantation in years and had no knowledge of any recent activity there. The men dismounted to investigate. On the mud banks, Lesesne saw a wooden walkway shaded by crepe myrtles and oleanders leading to a short ramp for small boats and canoes.

The men followed the walkway and soon found another wooden path running in another direction through the trees. At the end of that path they arrived at another clearing, whereupon an African man exited a wooden hut, aiming a gun at them. Primus raised his rifle and the two men engaged in a standoff, yelling at each other in Gullah.

At this point, over a dozen other Africans emerged from behind the thick trees and Lesesne ordered Primus to lower his rifle. As he did so, the other man also slowly lowered his gun to his side. Lesesne asked Friday to find out who the men were.

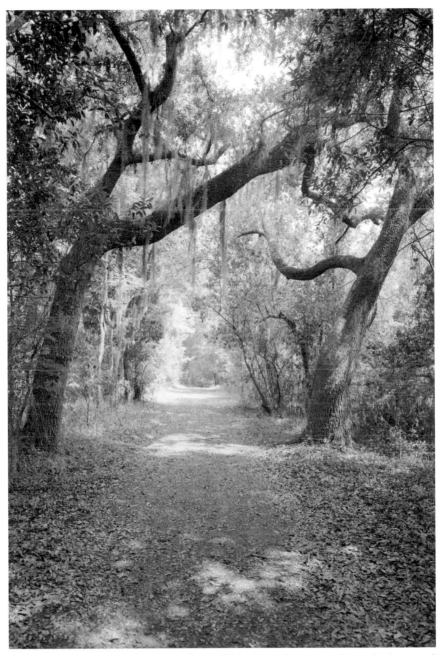

Master Lesesne traveled with his family by horse and carriage down the long path to the plantation loading docks.

Friday conversed with the man with the gun and replied that the man wanted to know who Master Lesesne was and why he was on their property. Lesesne then saw several West African style shacks through the trees. The homes looked fairly new, but a few had rusted tin roofs. The doors were painted haint blue, the traditional color used to deter ghosts and zombies.

Friday waited for Master Lesesne's response. Lesesne, fearing more confrontation, turned to walk away. He surmised that these men were runaways from another plantation and had been using this corner of his property as a hideout. The hideout had turned into a residence. As long as the men didn't steal or cause any harm to his plantation, he would allow them to stay through the winter. When spring came, if they were still around, he would have Friday and Primus run them off.

By the time Master Lesesne returned to the main house, he had counted 120 slaves. He was nervous, imagining other groups of freedmen or runaways living along the outskirts of his plantation. He wondered if the men he saw in the woods communicated with his slaves.

Over the course of the harvest season, Lesesne spent his time in the fields with his slaves. He walked around with the overseers and took water breaks with them. He asked the overseers to remind him of the names of his slaves, and to whose family they belonged. After a month of sweating in the indigo, cotton, and tomato fields with his plantation slaves, Lesesne felt confident that he still retained complete control over the population. He sensed, however, that he would have to confront the men in the woods to ask them to leave.

One night the following April, Master Lesesne awoke suddenly from his sleep. He heard a group of people hollering behind the fields. He ordered his wife to lock the doors, grabbed his rifle, and headed out into the dark night.

Lesesne woke up Primus in his cabin and asked him to get his rifle and follow him to see what the commotion was about. The men did not bother with horses, instead walking a half mile into the woods with Primus holding a lantern.

The night air was crisp and cool when they came to the foot of the wooden walkway by the river where the men had confronted them last fall, and the sound of voices had intensified. Through the trees, Lesesne and his overseer discerned the outlines of 50 to 60 people crowded around a large bonfire.

One man, whom Lesesne recognized as the one he had encountered in the woods, was holding a large torch and shouting in a strange language to the crowd. Lesesne made out the faces of many of his slaves as the light of the flames danced upon their faces. They were murmuring and nodding their heads.

Another man arose from the large group. He held a live gamecock in his hand. The bird was screaming and jerking from side to side. The man was tall, thin, and darker than most of the group. He had seashells braided throughout his long hair. He lifted the gamecock up to his mouth and bit into its neck.

Blood burst from the man's mouth and the now motionless bird. The crowd reacted at once. Many left as the man went into convulsions with blood streaming down his chest. Others shouted and gathered close to him. As those leaving the bonfire ran away, Master Lesesne saw them heading his way.

Lesesne ordered Primus to extinguish the lantern. The two men then turned and sprinted away from the bonfire. As they ran, they heard dozens of people running behind them, some screaming. Lesesne, well into middle age, was not able to keep up with Primus. He ran to the side of the path and hid in the darkness, watching the slaves race past him. When he thought it was clear, Lesesne crept out into the open. He peered into the darkness of the trees and strained to hear anything closer to him than the distant shouts of the people.

When Lesesne returned to his house, Primus was on the porch waiting for him. Lesesne ordered him to retire and entered the house. His wife and children had gathered in the kitchen with the house servant, their wide eyes telling of their fright.

The next morning, Primus knocked on Master Lesesne's door during breakfast. His eyes were shifting in different directions as he approached his master. Primus explained that none of the slaves had shown up for work at sunrise. He went to their cabins, and none of them were even home. A little boy walking around the cabins had told him that they were in the boats with the holy man. Primus didn't know what the boy meant, but told Lesesne that he knew there was no way he and Friday could whip so many slaves.

That day, the fields remained empty except for the few loyal overseers walking around in disbelief. Except for holidays, the slaves had never missed work. The message of the slaves' departure was clear: a confrontation was inevitable.

Lesesne looked over his cousin's letter from New Orleans from the past October, re-reading it several times.

That day, he enlisted the house servants and overseers to help him pack all of the family's valuables onto a large wagon. He planned to leave the island that night by boat from the ferry landing on the east side. Every heirloom was gathered from the house that day, though many possessions were too heavy or too large to fit onto the wagon.

As the sun set beyond Charleston Harbor, Lesesne gathered his family at the kitchen table. The house servants and overseers ate dinner in the other room.

Many of Lesesne's children were sobbing. His wife had made venison stew. It was their last supper on the family plantation.

After they ate, the family gathered around the table and told stories about the plantation's history. Lesesne planned to wait until after the slaves went to sleep to depart. The wagon was loaded and the plantation was eerily quiet.

Late that evening, the family climbed onto the wagon with Primus, Friday, and a few of the house servants. Master Lesesne called to the horses. They headed toward the ferry landing.

A quarter of a mile toward the landing, the horses began to neigh and slow down. The overseers and house servants jumped off the wagon and ran into the thick woods. Lesesne's wife winced as she grabbed onto her husband. Master Lesesne whipped the horses and they slowly advanced.

In the distance they could see the water where they would load the wagon onto their boat. Master Lesesne whipped the horses to move faster, but they cried and whimpered as they neared the approach to the landing.

Then the edge of the forest ignited with fire. At first there were a few flames from torches, then a dozen. Soon

there were over a hundred torches burning brightly. Master Lesesne's slaves held the flames high along the path to the landing.

The horses kicked and cried but continued to move in the direction of the landing. Lesesne's children whimpered as he shouted that he wanted no trouble.

As the wagon drew closer to the landing, the slaves behind closed in to block the path back to the plantation house. The slaves in front remained to the side.

Master Lesesne recognized the faces of many of the slaves as he passed through the tunnel of flames. He saw slaves bowing down with their torches as he passed.

At the end of the path, Primus and Friday were holding the ferry's mooring lines next to the ramp and the horses pulled the wagon onto the boat. Master Lesesne slowly turned around as he felt the boat drifting away from the landing. He watched Primus and Friday toss the boat's lines high into the air as they joined their fellow slaves in newfound freedom.

Master Lesesne bowed his head as he saw over a hundred of his former slaves gathering around the landing. He had just left his entire plantation to them.

With the physical and emotional tumult that accompanied slave life on many plantations, it is easy to recognize why tormented spirits might crystallize around these properties.

Plantation slaves were allotted particular areas for their living quarters—slaves who worked in the plantation house or in the barns enjoyed better living conditions than the larger majority of field hands. On some plantations, the owners provided all the necessities for their slaves, from housing to food and clothing. On others, the slaves built their own cabins. These tended to be reminiscent of houses in the Caribbean islands or West Africa, with thatched roofs and close proximity to the water. Some were adorned with "haint blue" paint on the door or inside walls near the beds for protection from wandering spirits or haints. As slave populations swelled in the eighteenth century, living conditions became cramped with sometimes as many as ten people sharing a hut.

Slaves had little furniture except for what they found time to create—their beds were usually hay or cotton. The long hours they had to work meant that they had little free time for making things to improve their living conditions. Because some slaves were without the basic necessities of pots and pans, they used a hollowed out pumpkin shell, called a calabash, to cook their food.

The photographs on the following pages reveal the variety of slave cabins across the Lowcountry where slaves lived and where some of their ghosts may still linger.

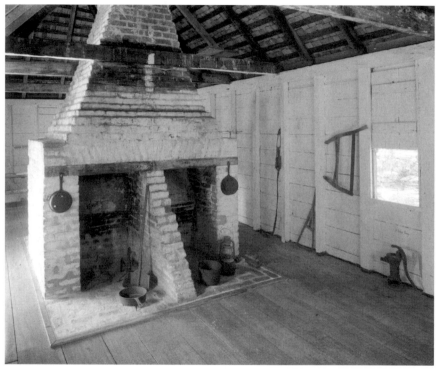

The thatched-roof interior and double fireplace of this slave cabin shows how two or more families lived on the North Santee River at Hopsewee Plantation near Georgetown, South Carolina.

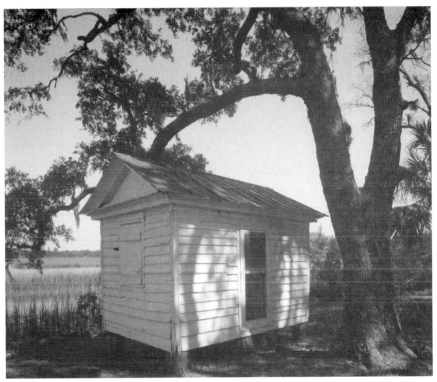

This Stone Creek cabin on Sunnyside Plantation on Edisto Island, South Carolina, shows just how cramped living conditions could be.

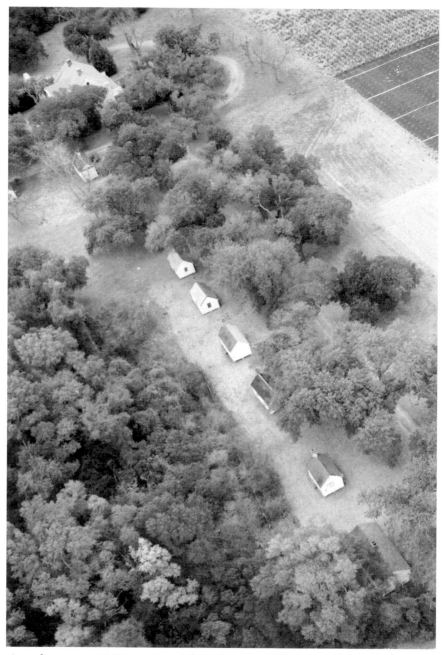

According to an 1860 census, 74 slaves lived in 26 cabins at McLeod Plantation on James Island, South Carolina. Nine 20-foot by 12-foot cabins remain today and were rented out to local families by William McLeod until he died in 1990 at 105.

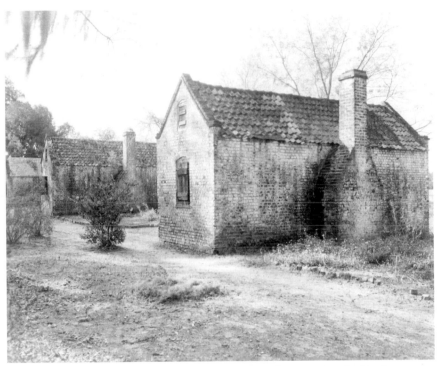

The "Slave Street" cabins at Boone Hall in Mt. Pleasant, South Carolina, were made from kilns at the plantation brickyard on Wampancheone Creek. They are believed to be the only brick slave cabins remaining in the United States.

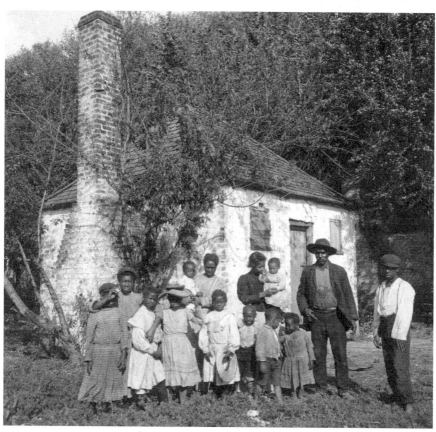

The Whole family posed outside this former slave cabin at the Hermitage Plantation near Savannah, c. 1907.

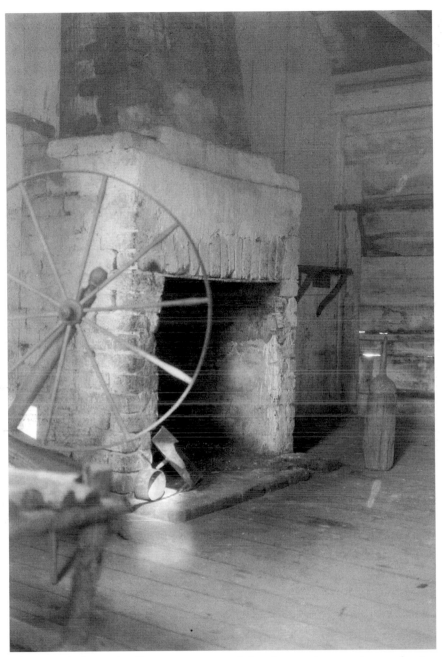

This marsh-front dwelling was occupied by slaves whose main production was rice. It is the only one that remains on the Isle of Hope near the city of Savannah, Georgia.

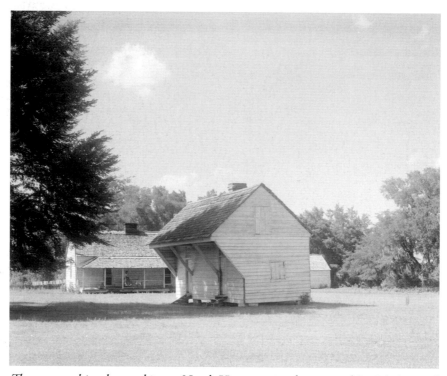

The snow-white slave cabins at North Hampton in the original St. John's Parish in Berkeley, South Carolina, show innovation in design. The plantation dates to 1716.

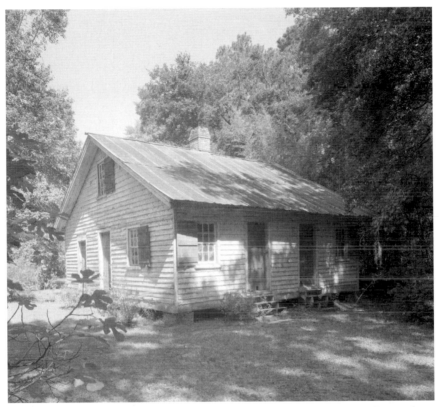

This double slave cabin on Wicklow Plantation in Georgetown, South Carolina, dates to 1825–1832. The slaves who lived here produced rice for the 190-acre plantation on the North Santee River.

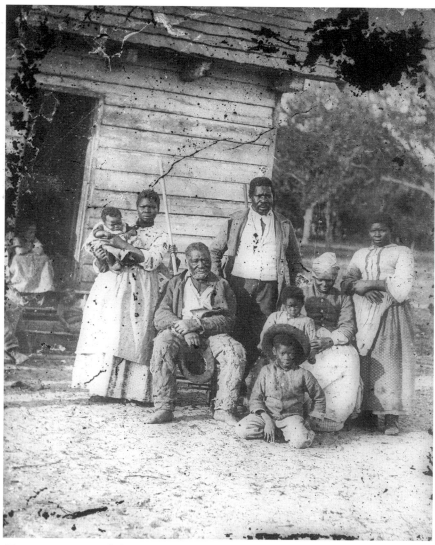

Five generations of this family were photographed together outside a cabin on Smith's Plantation near Beaufort, South Carolina, in 1862.

The Mummy and the Lost Tribe

A mummy is in the museum in Charleston. The preserved remains from ancient Egypt date back to around 30 B.C. The black linen on the face has been removed to show the features of a 20- to 40-year-old woman. Through the empty eye sockets, a person can almost see into the hollow darkness of the ancient African's head. According to the beliefs of this person's culture, her spirit is preserved within.

The mummy in its glass case has been seen by thousands of visitors over the years, with mixed reactions. It was bought by Gabriel Manigault in 1912 from a western diplomat who purchased the mummy in a tomb near Cairo, Egypt. Manigault, a descendant of one of the earliest French Huguenot families in Charleston, intended for the mummy to be shown in the museum to give locals an appreciation of ancient North African culture.

A few years ago, a healthy, 35-year-old tourist from Mississippi stepped into the museum for his first look at the mummy. He moved close to the case and stared intently at the black face. Nobody will ever know what he saw. Within moments, the man collapsed on top of the glass.

The man was still standing on both feet when museum guards arrived. The upper half of his body was resting on top of the mummy's glass case, just as they had seen him on their security monitors.

At first the guards were more worried about vandalism to the mummy, but when they saw the man's face, they alerted the head of the museum to close down and called for an ambulance.

When I first heard about the Egyptian mummy and the Mississippian's unexplained heart attack, I had recently interviewed an immigrant from Nigeria for this book. *Haunted Plantations* was in its early stages and my aim was simply to research evidence of supernatural activity in the spotty historical records of slavery and plantations.

I was teaching British literature to senior students at Eau Claire High School in urban Columbia at the time and living in a small nearby town called Camden. One day I needed a taxi to go from Eau Claire to the Columbia airport to pick up a rental car. After completing my overview of the European tribes in *Beowulf* for my last class of the day, I stepped outside to the waiting cab.

The driver's name was Tafawa. I asked him where he was from when I noticed his thick West African accent. He said he was a member of the modern-day Igbo people of Nigeria. He came to South Carolina because he had family roots here dating back to the 17th century.

Tafawa spoke about his life in West Africa compared with his life now in the United States. Technology made it possible for him to communicate easily with family members on both sides of the Atlantic. But one of the most fascinating things Tafawa revealed is that the Igbo's lineage can be traced directly back to Israel.

The Igbo are believed by some to be one of the lost tribes of Israel. Many Nigerian Jews claim that families in their communities are descendants of Kohanim and Levites, the Jewish priests who operated in the Temple of Jerusalem. Israel has yet to recognize the Igbo as one of the lost tribes, and one reason why may be that Israel has enjoyed good relations with Nigeria, where the Igbo have been considered a secessionist tribe since the Nigerian Civil War ended in 1970. Chief Ojukwu of the Igbo led Biafara, a secessionist state, during this war and he was exiled to the Ivory Coast for 13 years afterwards. He has since returned to live peacefully in his country.

My ride took on a magical quality. I was riding shotgun with a link to one of the unknown mysteries of the Middle East. Somewhere in the holy lands between Israel and Egypt, where children today might be picking fresh, ripe strawberries in Gaza, this man's ancestors lived.

When Tafawa dropped me off at the airport, I was pleased that this chance encounter had led to such a bright revelation. I handed him a few dollars extra for gratuity, glancing at the Egyptian pyramids on the backs of the American bills as I did so. I scribbled down his phone number so I could call him if I had any more questions, which I inevitably did.

Many people associate human bondage primarily with the American south. The dark roots of slavery, however, according to many sources both religious and historical, can be linked to early North African civilizations.

Ancient testaments tell the story of the Judeo-Christian prophet Moses helping the Israelites to flee their slave masters in Egypt. After they crossed safely out of Egypt, the

Egyptian army and the slave masters who had been chasing after them were drowned.

According to Igbo tradition, most of the Jewish people fled away from the Middle East into Canon, or what is now Palestine. Tafawa believes that many also fled Egyptian slave masters for West Africa. They settled in places like the Congo, Nigeria, Senegal, Ivory Coast, and Mozambique, trying to avoid Islamic domination as they came into these unclaimed, rural lands. Most of the western African lands became, many centuries later, the battlegrounds where the Igbo would be captured and transported once again as slaves to the American south— mainly Charleston.

From West Africa, nearly half of those taken into slavery to North America wound up on the shores of South Carolina. It may be a paradoxical coincidence, or just fate, that a North African mummy from the ancient roots of slavery forms the centerpiece of a cultural display in the largest slave port in the United States.

The mummified woman's identity is not fully known. Mummification was extremely popular for pharaohs and high priests. The culture of death and obsession with mummification peaked during the reign of Cleopatra. Although slavery was widespread in this culture as well, it is estimated that Lowcountry slaves in the American south moved 700,000 more tons of material making the dikes for rice fields and the bricks for construction than the African slaves moved in stones during the construction of the Egyptian pyramids. As a mummified woman, it is possible

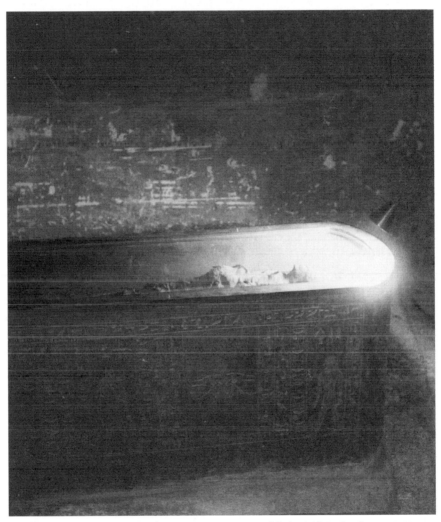

The mummy in the Charleston Museum was likely a female slave master in North Africa during the construction of the pyramids.

that the Egyptian in the Charleston museum likely was a slave master during her time.

During mummification, the woman's brains were removed through the nostrils with a hook. The blood and internal organs were carefully removed. Natron, a salt-based mixture, desiccated the body for 40 days so that it became tough. The body was then anointed with hot resins that melted with the Natron salts to produce a brittle glass-like covering on the body.

Two weeks were set aside for wrapping the body in linen. Wrapping was done ritually, with the insertion of amulets and prayer pillows. The scarab beetle was the greatest amulet, since it was believed to be born magically without an egg, and it also represented the sun god Kephir. Many archeologists have uncovered mummies and found them covered with hundreds of these beetles. Priests chanted spells during this process, using incantations from the Egyptian Book of the Dead. Finally, a sarcophagus was used as an encasement for the mummified body.

While President Abraham Lincoln was governing during the bloodshed of the Civil War, this mummy was just beginning to rise from the tomb where she had silently rested among scarabs and spells for thousands of years. Her destiny eventually took her to Charleston, where the defiance over slavery began. It was in Charleston where the war that would cost over 600,000 lives began. If Moses parted the Red Sea to free the Jews in Egypt, it was Lincoln who parted a symbolic sea of blood in America, freeing the Igbo tribe's descendants from their terrible plight.

Americans have risen above the immorality of human bondage to a freer, more sophisticated form of labor. In this

new world Americans are free, if only to the trust in the god of their dollar bills. And the same symbolic image on this powerful paper ties back to the Masonic roots of Egyptian pyramids.

Thomas Wolfe, in *You Can't Go Home Again*, saw the parallel with the post-reconstruction south's economy and the pyramids in a powerful way. On each of the 13 layers of a pyramid, a command is given for the sub layer to work. From the top of the pyramid, the smallest layer gives the command softly. The next layer down gives the command more firmly and louder in order for it to reach the larger layer beneath. This continues until the bottom layer is being shouted at and whipped as the masses move frantically to work and avoid punishment.

Perhaps it was the fire at the bottom layer of a pyramid that the Mississippi man saw in the Egyptian mummy's eyes. If he had survived, he might speak of the taste of blood from a master's whipping or the pain of a shackle tightened too much in the hot African sands. He may have witnessed a high priest's spell, heart-stopping in its terror. The deeper his gaze fell into the mummy's eyes, the more he may have come to know firsthand the spirit of an ancient sun god, a black beetle intoxicated with nothing, whole head and perfect circle, burnt, vaporized, and feeding only on its own mysteries.